Gauguin

Phidal

"Where Do We Come from? What Are We? Where Are We Going?"

Paul Gauguin

"The real traveller is one who sets out and never looks back" wrote Charles Baudelaire.

Paul Gauguin, painting's "poète maudit", took him literally.

He fled the conventions, – the routine and the boredom of civilization, Paris and Europe, to travel towards the unknown, the exotic and the primitive, towards the Utopia of a different world, closer to nature and more human – only to die tragically, with all his illusions shattered, alone, desperate and misunderstood, on the South Sea islands he had longed for and suffered for so much.

Paul Gauguin is a name indelibly linked with legend, with the myth of the rebel, the outcast and the vagabond.

But this name also symbolizes a new, essential, synthetic way of painting, completely free from preconceived ideas and theories, where pure technique reigns supreme. He was one of the precursors of modern art, who was not content simply to imitate nature, but wished to capture its innermost essence with a new intensity of emotion and a new spontaneity of expression.

His destiny appeared to have been preordained.

Gauguin's personality seems partly to have been inherited from his maternal grandparents: Flora Tristan, of Peruvian origin, self-assured and independent, who devoted much of her life to travelling and to following her ideals, and André-François Chazal, an engraver, sentenced to hard labour for attempting to murder his wife.

And there was Gauguin's first flight from Paris in the year immediately following his birth (June 7th, 1848), when his father, a journalist for *Le National* and an avowed opponent of Louis Napoleon Bonaparte, had to leave France hurriedly to take refuge with his family in Peru where his wife, Aline, still had some family connections. During the journey his father died suddenly and Paul, his mother, and his sister settled in South America where they stayed until 1855.

Ten years later he signed up for the Navy and served without any particular heroism until the end of the Franco-Prussian War in 1870. His mother had died in 1867 and, though alone in the world, Gauguin had the firm support of his guardian Gustave Arosa. Chance had it that Arosa, an art lover, possessed a fine collection of contemporary paint-

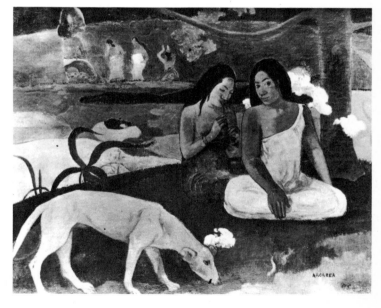

Arearea (Joyousness), 1892. Musée du Louvre, Paris.

ings including works by Delacroix, Corot, Courbet, Daumier, and Pissarro. The period that followed was a quiet one, though highly productive.

Gauguin worked as a clerk with the Paris broker Bertin, and devoted himself to art, poetry, and literature.

His successful speculation on the Stock Exchange earned Gauguin a good living, and in 1873 he married a rich, young Danish girl named Mette Gad. During the same period he regularly visited museums and art exhibitions and also began to draw and paint. He would stroll into the country with his friend and colleague Emile Schuffenecker, with his brushes, paints and canvas tucked under his arm.

At this time, however, he painted only for pleasure and it was far from being his main concern in life.

Very soon, however, he began to take an interest in the Impressionist movement and even bought some canvases by Cézanne, Sisley, Degas, Monet and Pissarro. Then, in 1876, he chanced sending one of his paintings, a landscape inspired by Millet, to the Salon des Artistes Français. It was accepted. At the same time, he began trying his hand at sculpture producing several busts of his wife and children.

Although he had struck up a friendship with Pissarro and had great admiration for Cézanne, for the moment his models remained Millet and Delacroix. He was soon to cease being a Sunday painter. As his technique improved, his desire to master all the aspects of painting increased, and he painted at every possible moment.

Painting, in other words, had become a vital necessity.

He began to study Japanese prints and to take part in the debates that divided the artists of his day, without, however, neglecting discussions regarding matters of technique.

For the moment there was nothing to stop him from continuing with his job: his colleagues perhaps thought him rather odd but he was still quite successful as a stockbroker.

But his life was about to take a decisive turn, the prelude to which was the invitation he received from Pissarro in 1880 to take part in the 5th Impressionist Exhibition. The following year the novelist J.K. Huysmans, writing in *L'Art Moderne*, had this to say about his *Study of a Nude (Suzanne Sewing)*: "I do not hesitate to assert that among contemporary painters who have worked at the nude, not one has been able to render it with such vehement realism.... Gauguin is the first artist in years who has attempted to represent the woman of our day... His success is complete and he has created a bold and authentic canvas".

In 1882, almost as if destiny were taking the upper hand, the financial world put Gauguin in a position where he was forced to choose painting as his career. There was a serious financial crash and both Gauguin and Schuffenecker left the Stock Exchange for good.

At this point his only hope was that he would be able to make a living by painting, but unfortunately this was not to be. Persistent economic difficulties and the rejection of his work in Paris forced him to leave the capital. He moved with his family to Rouen where, contrary to his hopes and expectations, he came up against the same kind of difficulties he had encountered in Paris. Life was just as difficult in the provinces and Gauguin was at the end of his tether.

The only thing left was to go abroad, and so the family left for Copenhagen, seeking refuge with Mette's family and friends. This time, however, Gauguin had a job waiting for him in Denmark: an appointment as representative for Dillies & Co., a manufacturer of weatherproof canvas and tarpaulins which he hoped to sell to Danish shipbuilders. It was a dual failure, financial and social, for Gauguin refused to accept the rules of the bourgeois, conformist society in which his wife's family lived.

He returned to Paris with Clovis, one of his five children. Poverty awaited them. In order to make ends meet and to pay for medical care for his son who had come down with smallpox, Gauguin took a job as a billsticker. He continued to paint, but even his painting did not satisfy him. He felt as if he were at a dead end; he wanted to find his own genre, to get away from the past and even from the artists who had previously influenced his work and contributed to his artistic formation.

This was perhaps his first real break with the world that surrounded him. His hardship and his distaste for civilisation were pressing him to go off in search of a better world. He was by no means the first to do so: many artists before him had written about the same feelings, and had sought consolation in artificial paradises, abstract, melancholy, aesthetic existences, or flights towards far-off shores. Baudelaire, Verlaine, Rimbaud, and all the born wanderers before them who had ended up in Paris and, with survival as their symbol, had lived their lives on the edge of society, going from one "brasserie" to the next, always far from the monotony and mediocrity of bourgeois values. Or consider the generation of the Romantics, with their dreams and their ideals of freedom dramatically linked to political struggles; Jean-Jacques Rousseau with his myth of the return to nature opposing a false idea of progress, which instead of helping man find happiness, makes him a slave to prejudice and hypocrisy. The defeat of the Commune made people question this thinking. It meant a move from a historically objective experience to an inner subjective dimension; the age of illusions had come to an end, at least for those who chose not to side with "civilization". Gauguin felt more and more alone, uprooted and disheartened. He did not share the values he saw growing up all around him – profit, order, serenity and security. He hated anything commonplace or banal. He isolated himself from the world in the manner of Des Esseintes, the decadent hero created by Huysmans. Or rather he chose to escape, to run away from reality. Escape had been turned into an intellectual concept by Stéphane Mallarmé and those like him who wished to keep their distance from naturalist concepts which they deemed superficial. It had become a kind of password for those such as Rimbaud or Delacroix who actually set off in search of a better, more authentic way of life. Away from Paris, first, and then away from time and civilization.

Thus, in 1886, the year of the 8th and last Impressionist Exhibition, Gauguin went to Pont-Aven in Brittany for the first time, staying at Madame Gloanec's inn, a cheap boarding-house where artists were sure of a friendly welcome. Here he made the acquaintance of the pupils of the Cormon and Julian schools, very much in fashion at the time in Paris. Their academic approach to painting bored him, however, and he kept his distance. Despite the fact that all the other painters were impressed by his strong artistic personality, he only really made friends with Charles Laval.

During his stay in Brittany he gave a lot of thought to the importance of giving his work a wider, more detached dimension. With his passionate, exuberant temperament he managed to put his feelings on canvas, expressing all the sensations he felt towards this wild, archaic land. He no longer held back from expressing all that his previous experiences had taught him, and his first works in Brittany are fine examples of the conflict inside him – half-way between dream and reality, between aesthetic complacence and allusive vision. Although they show that he had not yet completely broken away from Impressionism, they nevertheless represent the beginning of a change. Gauguin was slowly moving away from a period which had seen the birth and development of a lively artistic movement whose keynote had been dynamism.

Gauguin no longer viewed nature in an idyllic fashion. Nature became as tormented as the brushstrokes used to represent it. It had a new rhythm and new effects of colour.

In certain paintings such as *Breton Coast*, it is possible to see not only the lessons learned from Impressionism but also a more aggressive approach and clearer tones, the marks of a painter trying to find his

own, new way – a less intellectual way which allowed inner feelings to be more freely, more simply expressed.

In August, Emile Bernard arrived in Brittany. He was only nineteen and appeared to have some reservations about the work of the master. But on the whole, the imagination and originality of composition of Gauguin's Breton paintings greatly impressed all the artists who saw them at Pont-Aven during the summer of 1886. News of the paintings spread to Paris and soon Vincent van Gogh was anxious to meet Gauguin. The two artists first met in November of that year, a month after Gauguin's return to Paris where he had refused to take part in the Salon des Indépendants. During the same winter Gauguin worked with the ceramist Ernest Chaplet, to whom he had been introduced by the engraver Félix Bracquemond, who taught him the basics of his art. Gauguin, however, was still more interested in drawing and in the stylized structure of the works of the primitives, and his subjects were Peruvian objects that reminded him of the land of his "ancestors" and his adolescent fantasies. Alternatively, Oriental objects with their plain contours and colours were to prove extremely important for his studies and for the evolution of his art.

But Paul Gauguin was as restless as ever and decided to leave Paris again. He again felt the need to rediscover his lost vitality, far from the anguish and frustration of civilization. He again sought the energy he needed to continue working with enthusiasm or, more simply, to continue to live. His life lacked the excitement, the colour, and the magic of nature. So, in April, he hastily decided to set off across the ocean with his friend Charles Laval to Panama where his idea was to live "like a native". Unfortunately his dreams failed to come true: he was soon disappointed with Panama and moved to Martinique. Here he fell ill and was forced to return penniless to France at the beginning of winter. Luckily, this unhappy dip into the exotic was not without benefit for his work: the paintings and sketches he made during the journey began to show the characteristics of a new personal style. Back in France, Schuffenecker put him up as usual and Théo van Gogh, Vincent's brother, arranged for an exhibition of his latest works to be held at the Boussod-Valadon Gallery in January 1888. It turned out to be a failure. Shortly afterwards Gauguin again left Paris, the spectre of a society foreign to him and with which his only relationship was one of mutual rejection. He took refuge again in the calm and quiet of Pont-Aven, the place he had found so congenial to his thoughts two years earlier.

He had already accepted the message of Cézanne and Postimpressionism and appreciated the importance of colour used not only to create light and movement but also to define shapes so that the colour itself became a shape of its own. After Martinique his colours had become warmer, with greater contrast of shades and clearer outlines. His wish was to create an abstract composition in which nature moved further and further away from reality and came near to being imaginary. In Brittany he was to achieve just this.

With long, generous strokes of pure colour he created rhythm and contrast, broke up surfaces, created form and organized space, always giving prominence to human figures which, regardless of whether or not they were the main subject of the canvas, were always an essential part of the narrative, with their sombre, precise outlines serving to organize the form and separate the colours. This style – these "poetics" – was called *Synthetism* and was studied and then transformed into the *Cloisonnisme* which Emile Bernard and Louis Anquetin had been experimenting with and which was aesthetically linked to stained-glass church windows and medieval enamels. But whereas Bernard's Synthetism was limited to an abstractly linear conception, Gauguin's transformed all that was still intact in the civilized world into simplified, idealized, yet highly expressive images.

The result was a kind of symbolism wherein the entire figurative aspect became a search for the essential.

Jacob Wrestling with the Angel (The Vision after the Sermon) is one of the most significant examples of Gauguin's radical change of style. It is a synthesis of harmony and balance, where references to medieval and Japanese art mingle with Gauguin's decorative inspiration – a painting animated by the rhythm of the shades of black and white, blue and red. The move away from the exact representation of nature had been made. What Gauguin was trying to do now was to enter the heart of things, to penetrate reality, to see and comprehend what lay behind reality or, to use his own words, to uncover "the image behind the inviolable enigma". What really counted in his painting was the essential synthesis of form and colour. He sought an art that was completely free of any preconceived formula, technique, school, movement, or style: an art which reflected only the individuality of the artist.

Nevertheless these ideas – which were in some ways similar to literary inspiration, lying as they did on the boundaries between fiction, dream, and reality – attracted not only Gauguin but also several other artists of the day. Chief among these was Emile Bernard, who not only influenced and stimulated Gauguin with his ideas and research, but also involved him in long analytical discussions about spontaneous art – whether primitive, popular or infantile – or about the importance of reviving, at least in art, certain religious myths whose mystic, sentimental roots lay deep in the hearts and imaginations of ordinary people and as such seemed to fit Gauguin's ideas perfectly.

In Gauguin's work, myths blend with mystery. He drew his inspiration from the art of the past: chapels, crucifixes, sculptures, and wayside shrines that were everywhere to be found in Brittany. *Jacob Wrestling with the Angel (The Vision after the Sermon)* can without doubt be considered a prelude to Gauguin's re-examination of the sacred genre, the later examples of which, spiritually more intense, are *The Yellow Christ*, which represents Christ in the chapel of Trémalo, and *The Green Christ (Breton Calvary)*, inspired by the wayside shrine at Nizon. Both are dated 1889, both are set against a background which sets off the same unreal colours of the Christ, and in both, the figures of the peasants in the background and the Breton women in the foreground emphasize the deliberate naivety of the composition. In *Christ in the Garden of Olives* Gauguin portrays himself with the features of Christ, and in *Self-Portrait with the Yellow Christ*, a painting which belonged for a long time to Madame Gloanec before it was purchased by Maurice Denis, Gauguin stresses the self-portrait aspect further. This is in fact another theme which makes Gauguin a precursor of the modern tendency of making new variations on familiar religious subjects.

In 1888 Sérusier, a member of the Nabis movement, took back with him to Paris a picture called *The Talisman* which was emblematic of the period spent at Pont-Aven and played a decisive part in his artistic formation. He had painted it at the Bois d'Amour under the direct guidance of Gauguin who had been fascinated by his way of interpreting nature. Nature, he learned, should not be represented exactly as it was: the colours should hint at its hidden identity.

As Gauguin wrote to Schuffenecker in 1888: "Art is an abstraction. Draw it forth from nature by reaming in front of her and think more of creation than the end result". Or in September of the same year to Van Gogh: "I find that everything is poetic and that it is in the dark and sometimes mysterious corners of my heart that I feel the poetry. Forms and colours, harmoniously arranged, are themselves poetry".

Van Gogh had moved to Arles and was trying to persuade Gauguin, with whom he had corresponded regularly for some time to come and live in Provence. In the end Gauguin gave in, partly because he quite liked the idea that other painters might come too and form a real group of independent artists. Other painters had done so (the Pre-Raphaelites, for instance, had set up such a group in England in 1848) and it may have helped to sell a few paintings. Unfortunately the dream never came true because the differences between the two artists were so

great. Obviously they had certain things in common: they both started painting late in life and they were both self-taught. Gauguin, however, was more cynical, more ambitious and less romantic than Van Gogh who looked upon art as a mission. In Van Gogh's work the forms and colours aim at communicating the artist's own excitement and impulsiveness: they emphasize the emotional aspect so much that reality becomes deformed. In a word, Van Gogh painted with the frenzy of a writer carried away by inspiration. Gauguin, on the other hand, was more decorative and less dramatic, and thought of painting as an abstraction, a poetic evocation. Van Gogh liked Daumier and Rousseau; Gauguin preferred Ingres and Degas. The discussions turned into arguments and both Arles and Van Gogh himself began to irritate Gauguin. Things finally came to a head: "I had almost made my way across the Place Victor Hugo when I heard behind me a familiar step, rapid and jerky.... Vincent was coming at me with an open razor in his hand. The look in my eye at that moment must have been quite stern because he stopped and, bending his head, ran back to the house...." (Paul Gauguin in *Avant et Après*).

Later Van Gogh cut off his ear with the razor and Gauguin was arrested. As soon as he was set free he went back to Paris where Schuffenecker again put him up. In February 1889 he exhibited in Brussels with the group known as "Les Vingt" ("The Twenty") and from June to September, seventeen of his paintings were on show at the exhibition of the "Impressionist and Synthetist Group" at the Café Volpini in the Champ de Mars at the entrance to the Paris World Fair. Several years later, Maurice Denis said this about the event: "For the first time the Synthetists and the whole Pont-Aven School, grouped around Gauguin and including Bernard, Anquetin, Laval, and Schuffenecker, exhibited their work in the Café Volpini. It may rightly be called an epoch-making demonstration. Held in a vulgar place of resort, this exhibition of a totally novel art marks the beginning of the reaction against Impressionism".

At the beginning of June, Gauguin went back to Pont-Aven and moved on to Le Pouldu in the summer. It was a period of reflection during which he painted religious subjects (*The Yellow Christ, The Green Christ*, etc.), landscapes, and portraits: *La Belle Angèle at Le Pouldu (Portrait of Madame Angèle Satre)*, a portrait of his friend Meyer de Haan and one of a woman, perhaps Marie Derrien, known as "Lagadu", with a still life by Cézanne in the background – the same Cézanne who intended to astonish Paris with a "portrait" of an apple and whose plastic research still played a decisive role in the art of Gauguin. This can be seen by the way in which several still life studies painted by Gauguin during this period are clearly influenced by Cézanne's forms. Despite his friendship with Charles Morice, Mallarmé and the other symbolists who met regularly at the Café Voltaire, Gauguin continued to dream of far-away places, of an unspoiled Garden of Eden where he would be able to live and paint in a natural, primitive manner. At first he thought of going to Madagascar, but finally decided on Tahiti.

In 1891 he organized an auction sale of his works at the Hôtel Drouot, with the catalogue preface written by Octave Mirbeau; in the same year he quarrelled with both Schuffenecker and Bernard and after travelling to Copenhagen to say goodbye to his family he sailed from Marseilles for Papeete.

Life in Papeete, however, proved to be very similar to that which he had left behind in Europe, if not worse. Nevertheless the village of Mataiea, the lush tropical vegetation, the natives with their exotic dress and the natural way in which they went about their everyday lives and his love for Tehamana, his young "bride" of thirteen who also posed for him as a model, had all the appearance of a dream. This dream that was soon to be shattered by money worries and ill-health.

In *Noa-Noa* he wrote: "I left two years older, and twenty years younger, more of a barbarian too than when I came and yet more schooled. Yes, the savages have given many lessons to the old civilized man, many lessons from these ignorant people in the science of life and the art of being happy". The paintings he brought back with him from Tahiti, with exotic subjects and violent colours, appeared somewhat strange by the standards of old Europe. The exhibition held in Paris in November 1893, in the Durand-Ruel Gallery, bewildered the general public, art critics, and even fellow artists. Only eleven of the 45 paintings on display were sold. If Gauguin wished to appear a barbarian, foreign to the Western world, he certainly seemed to have achieved his aim.

Gauguin was not content with just painting the natives, their dark bodies, and the expression in their eyes: he wanted to enter the depths of their feelings. He wanted colour to express the gentleness, the peacefulness and the sensuality of the people and everything that belonged to them and surrounded them – the landscapes, the flowers, the idols, the "pareus" ... Obviously not all the vestiges of Western culture could be shaken off and forgotten even when portraying Tahiti and Polynesia. There is always a decorative, refined, intellectual side to even the simplest drawings and paintings.

For Gauguin, 1894 was marked by a series of unfortunate events. The death of his friend Charles Laval upset him. The trip he made to Brittany bore no fruit and Annah, his Javanese mistress, left him after taking everything of value she could find in his studio.

On July 3rd the following year Gauguin decided to cross the seas for the last time. And from that moment on his life has become mixed up with legend. In 1897 he painted *Where Do We Come from? What Are We? Where Are We Going?*, a large allegorical painting (139 cm. x 375 cm.) which, with great simplicity, represented the drama of human existence.

The question, which underlines the psychological content of the painting, reveals the artist's need to communicate his most deeply felt thoughts through the evocative force of art and colour, in a canvas painted in sombre colours. The question in the title reflected Gauguin's deep anguish which, as soon as the painting was finished, drove him to attempt suicide.

He was saved, life began again, and his next painting *Tahitian Pastoral (Faa Iheihe)*, painted in bright colours, is full of a newly found inner peace. Gauguin's situation, however, did not improve in any way. Oppressed by worries and with his health slowly deteriorating as a result of illness, he received the tragic news of the death of his son Clovis, aged 21.

He refused to give in: whenever his health allowed, he continued to draw, paint, and sculpt. He joined the natives in their struggles against the local authorities who were intent on imposing their own "white" codes of laws and morality on that of the islanders.

His last home was Atuana, one of the Marquesan Islands. He was completely alone. Ostracized by the French colonists, he was accused of defamation, tried and sentenced to three months' imprisonment and a 500 franc fine. He had called his house the "House of Enjoyment" and had the words "Be mysterious" and "Be loving and you will be happy" carved in wood above the door. It was his farewell to the world. He died in spring, on May 8th, 1903. As a last emblem of his personality, and of his refined exoticism in which his past was always present, upon his death a Brittany landscape was found, unfinished, on his easel.

He had just written these words to Daniel de Monfried: "In the isolation of a place like this a man's mind is reinvigorated. Here poetry arises all by itself, and to suggest that poetry, you have only to surrender to your dreams as you paint.... I feel that in art I am right, but will I have the strength to give it positive expression? In any case I shall have done my duty and even if my work does not endure, there will always remain the memory of an artist who freed painting from many of its old academic failings....."

6

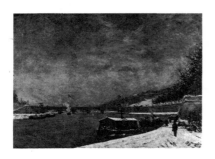

1. The Seine with the Pont d'Iéna – 1875. Musée du Louvre, Paris – *The theme of rivers and water is one of the predominant subjects in the works of open air painters. This is an example of a landscape painted by Gauguin, who was practically self-taught, at the very beginning of his career when he was still working as a stockbroker.*

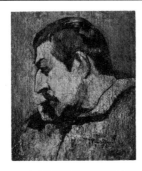

2. Self-Portrait Dedicated to My Friend Daniel – 1897. Musée d'Orsay, Paris – *Painted in Tahiti and sent to his friend Daniel de Monfreid in Paris in gratitude and in memory of his friendship, the intensity of the colours on this canvas and the expression on the face bear witness to how much Gauguin was suffering during this period.*

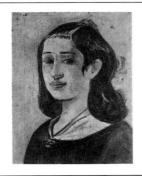

3. Portrait of the Artist's Mother – 1890. Staatsgalerie, Stuttgart – *Aline Chazal Gauguin, daughter of Flora Tristan, in a portrait which is a synthesis of a real portrait of Gauguin's mother, painted from an old photograph, and with his ideal of Polynesian beauty.*

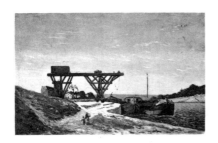

4. The Seine between Pont d'Iéna and Pont de Grenelle with the Cail Works – 1875. Private collection, USA – *In this early painting it is already possible to see the influence of Impressionism and the lessons learned from innovators of the technique such as Cézanne, Degas, Monet, Pissarro, Sisley and Renoir whose pictures Gauguin purchased at the start of his career.*

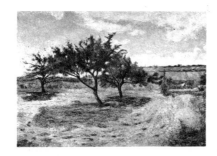

5. Apple Trees in Blossom – 1879. Private collection, USA – *Painted in the open air, the subject of apple trees recalls several other paintings on the same theme made by Pissarro at the start of the 1870s, including one canvas which very probably belonged to Gustave Arosa's collection.*

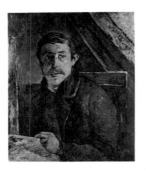

6. Self-Portrait at the Easel – 1885. Private collection, Bern – *This was the first self-portrait Gauguin ever did and several technical imperfections can be observed. Since he was looking at himself in a mirror he mistakenly drew himself left-handed and the hand holding the brush is slightly out of proportion to the rest of the painting.*

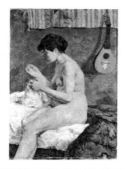

7. Study of a Nude (Suzanne Sewing) – 1880. Ny Carlsberg Glyptotek, Copenhagen – *This is an ambitious painting, modern in conception and also somewhat ironic. Gauguin's narrative realism is related to the art of Rembrandt and suits the novelty of the subject: a deliberately unattractive nude in an unusual pose, against a background whose originality is highlighted by the mandolin.*

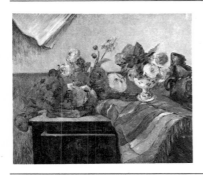

8. Asters on a Bureau – 1886. Private collection – *Still life themes are often to be found in Gauguin's work and here he reveals his interest in both Japanese art and decorative painting by his skilful orchestration and opposition of shapes and colours.*

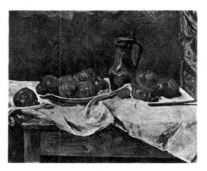

9. Still-Life with Tomatoes – 1883. Private collection – *At the time when Gauguin painted this still-life study, he was greatly influenced by Pissarro. Three years earlier, in 1880, Pissarro had invited him to take part in the 5th Impressionist Exhibition and when this study was painted Gauguin was working with Pissarro at Osny, near Pointoise.*

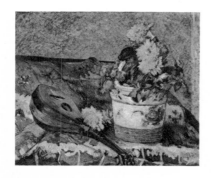

10. Mandolin and Pot of Flowers – 1883. Private collection, USA – *The central figures in this vibrant still-life study are the mandolin, a symbol of musical harmony, and the flower-pot, a decorative object whose dominant colour is white, as in a number of other such compositions dating back to the same period.*

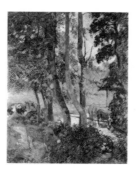

11. Pond with Cattle – 1885. Galleria d'Arte Moderna (Grassi Collection), Milan – *Fénéon said of this painting: "The colours are very similar to each other in this painting and this leads to a kind of dull harmony. Trees with thick foliage stand on humid, fertile ground and invade the whole canvas".*

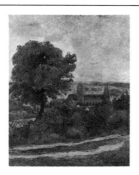

12. Rouen, Church of Saint-Ouen – 1884. Private collection, USA – *The influence of Impressionism can still be felt in this landscape. The painting is a document of the period Gauguin spent with his family in this provincial town where he arrived in 1883 in the hope of solving his problems.*

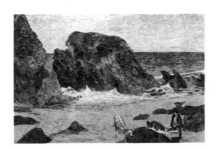

13. Breton Coast with Girl and Cows – 1886. Private collection, USA – *1886 was the year of his first voluntary exile from the civilized world. He went to Brittany, a wild, archaic region, populated by ordinary folk. Although still influenced by Impressionism, his painting depicted bleak landscapes and dream-like pastoral scenes which anticipated the direction it was later to take.*

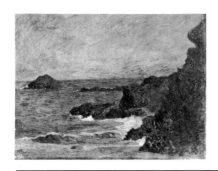

14. Breton Coast – 1886. Konstmuseum, Gothenburg – *This picture is no longer a mere imitation of nature. The aggressive brushstrokes and the bright colours used by the artist to paint the landscape reflect his need to free himself from the set theories and styles of his period.*

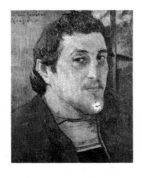

15. Self-Portrait Dedicated to Eugène Carrière – 1890. National Gallery of Art (Mr and Mrs Paul Mellon Collection), Washington, D.C. – *Gauguin had met Eugène Carrière by 1890 and must have seen him regularly the following year at the gatherings of symbolist painters in the Café Voltaire. Gauguin gave this portrait to Carrière in 1891 to thank him for his own* Portrait of Paul Gauguin. *It would appear, however, that the painting itself was completed some time before this date.*

16. By the Seashore (Martinique) – 1887. Ny Carlsberg Glyptotek, Copenhagen – *Although Gauguin's journey to Martinique was an unhappy one, it nevertheless enabled him to experience a world unspoilt by Western civilization and this had an influence on his painting. The colours he uses are now purer and brighter.*

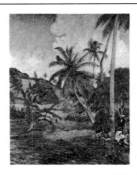

17. Palm Trees in Martinique – 1887. Private collection, USA – *The colours are different and the rhythm of the composition also changes, becoming more vibrant and immediate. The brushstrokes are longer and the shapes have darker outlines.*

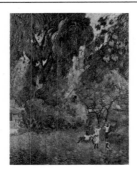

18. Huts under the Trees (Martinique) – 1887. Private collection, USA – *Gauguin's first strong reaction against Impressionism dates from his journey to Martinique. The lush vegetation is drawn with warm colours and entangled lines.*

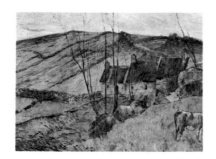

19. Breton Landscape – 1888. Private collection – *"I love Brittany: there I find the wild and primitive". On his second visit to Pont-Aven he started to paint with the new style that was later to be developed to the full in Tahiti.*

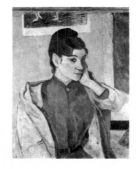

20. Portrait of Madeleine Bernard – 1888. Musée de Peinture et Sculpture, Grenoble – *In this portrait of Emile Bernard's sister, Gauguin's main concern was to convey the woman's character by means of the expression on her face. He wished to give the picture spontaneity and not just paint the clothes and the pose.*

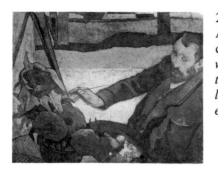

21. Portrait of Van Gogh Painting Sunflowers in Arles – 1888. Vincent Van Gogh Foundation, Amsterdam – *Van Gogh asked Gauguin to join him at Arles, where he lived, but the characters of the two artists and their ideas about painting were so different that this soon led to a dramatic separation. Van Gogh cut off part of his ear and Gauguin was arrested.*

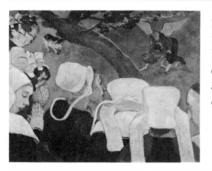

22. Jacob Wrestling with the Angel (The Vision after the Sermon) – 1888. National Gallery of Scotland, Edinburgh – *This picture is the most representative example of the new style known as synthetism which took shape in Brittany under the influence of Bernard. It is also Gauguin's first painting with a religious theme.*

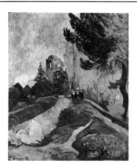

23. The Alyscamps in Arles – 1888. Musée d'Orsay, Paris – *The necropolis in Arles, with its melancholy cypress trees inspired both Gauguin and Van Gogh. The violent, arbitrary use of colours like yellow, red and blue, as seen, for example, in the tree trunk in the foreground, gives a foretaste of modern art.*

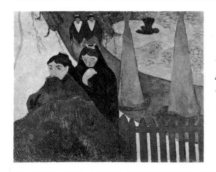

24. Women of Arles – 1888. Art Institute of Chicago (Mr. and Mrs. Lewis L. Coburn Memorial Collection) – *Exact representation of reality is relegated into second place by the imagination of the artist who interprets the shapes and the colours according to his own whims and to the contrasts he wishes to create on the canvas.*

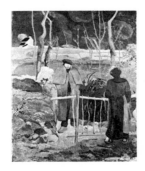

25. Bonjour Monsieur Gauguin – 1889. Museum of Modern Art, Prague – *A self-portrait on the theme of the artist as a lonely wanderer, inspired by Courbet's famous* Bonjour Monsieur Courbet. *Using colour contrasts Gauguin pictured himself extremely naturally, with a sombre, pensive expression on his face.*

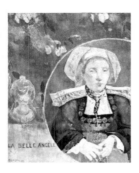

26. La Belle Angèle at Le Pouldu (Portrait of Madame Angèle Satre) – 1889. Musée d'Orsay, Paris – *A highly decorative painting where the novelty lies in the Japanese-style separation of the portrait of* La Belle Angèle *from the background by means of a circle. The woman in question is Marie-Angélique Satre, considered in Brittany to be a real beauty.*

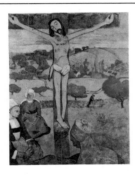

27. The Yellow Christ – 1889. Albright-Knox Art Gallery, Buffalo – *Gauguin set about painting this wooden statue of Christ in the chapel of Trémalo with the same ideal of simplicity that had inspired its original sculptor during the 18th century. The imaginary colours, the approximate shapes with dark blue outlines and the deliberate naivety of the picture are signs that Gauguin has reached full artistic maturity.*

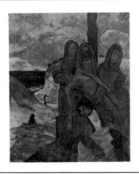

28. The Green Christ (Breton Calvary) – 1889. Musées Royaux des Beaux Arts de Belgique, Brussels – *This painting, with its mystic, religious theme, is an emblematic example of Gauguin's synthetism. The group with Christ, the colours of which blend in with the background, represents a wayside shrine at Nizon, near Pont-Aven.*

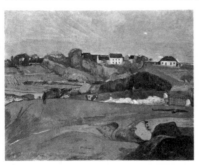

29. Landscape at Le Pouldu – 1890. National Gallery of Art (Mr and Mrs Paul Mellon Collection), Washington, D.C. – *This landscape is characteristic of Gauguin's synthetic art and belongs to the period the artist spent at Le Pouldu with his friend and disciple Meyer de Haan.*

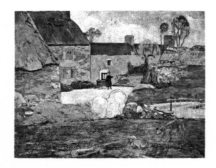

30. The Blue Roof (Farmyard at Le Pouldu) – 1890. Private collection – *"The village consisted of just four houses, two of which were inns; the more modest of the two seemed to be more pleasant and I went in because I was thirsty".* This is how André Gide described Le Pouldu and the inn belonging to Marie Henry where, quite by chance, he met Gauguin and the painters Sérusier and Filiger.*

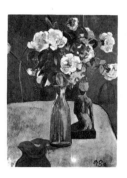

31. Roses and Statuette – c. 1890. Musée Saint-Denis, Reims – *The distinguishing feature of this painting is the originality of the composition. The surface of the table, which takes up almost the whole of the canvas, divides it into two different parts. The association of jug-vase and flowers-statuette (Gauguin's favourite statuette from Martinique) was later taken up by Matisse.*

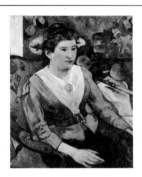

32. Portrait of a Woman with Still Life by Cézanne – 1890. Art Institute of Chicago (Joseph Winterbotham Collection) – *The influence of Cézanne on Gauguin is emphasized here by the still life study in the background. The still life in question is one from Gauguin's own collection. The identity of the woman is not certain: it could be Mette, or the beautiful Marie Henry of Le Pouldu, or again Marie Derrien, known as "Lagadu".*

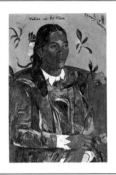

33. Tahitian Woman with Flowers ("Vahine No Te Tiare") – 1891. Ny Carlsberg Glyptotek, Copenhagen – *In 1891 Gauguin sailed for Papeete and then on to Mataiea in search of even more authentic nature, the lost paradise which seemed to be his only hope of finding happiness. He lived surrounded by natives and finally began to work in peace.*

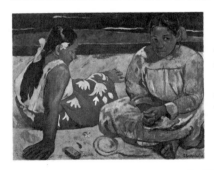

34. Two Tahitian Women on the Beach – 1891. Musée d'Orsay, Paris – *The two figures in the foreground recall Gauguin's Brittany paintings, though here they are accentuated by particularly deep, contrasting colours. The pattern of the Tahitian "pareu" adds vigour to the decorative effect of the picture which has an overwhelming sense of peace and calm.*

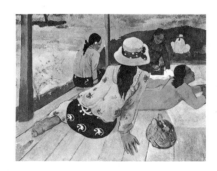

35. The Siesta – c. 1891-92. Private collection – *The lack of any signature, date, or title has led to much discussion as to exactly when this canvas was painted. Since other canvases with the same subject matter are all dated 1891 or 1892, it is probable that this one also belongs to the same period.*

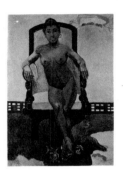

36. Annah the Javanese ("Aita Tamari Vahine Judith Te Parari") – 1893-94. Private collection – *Undated and unsigned, this detailed picture of a woman sitting in a chair with a monkey at her feet was painted by Gauguin on his return from his first journey to Tahiti. The woman is Gauguin's Javanese mistress Annah, with whom he lived until 1894 when Annah left him after looting his studio.*

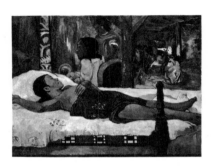

37. The Birth of Christ Son of God ("Te Tamari No Atua"), – 1895-96. Bayerische Staatsgemäldesammlungen, Munich – *This is the last of a series of paintings on the theme of the Nativity. It is interesting to note the bed, something entirely unknown in Tahitian culture. In the painting Gauguin used the same decorative element as that found in* Aita Tamari Vahine Judith Te Parari.

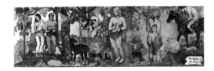

38. Tahitian Pastoral ("Faa Iheihe") – 1898. Tate Gallery, London – *The evocative, symbolic language of this painting and its brilliant colours represent the harmony in which man lives with nature in this part of the world. This was the first picture Gauguin painted after his suicide attempt and represents the start of a new cycle of works where the artist's inner peace of mind can be clearly felt.*

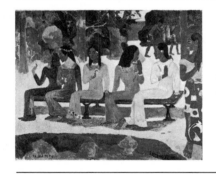

39. We Shall Not Go to Market Today ("Ta Matete") – 1892. Oeffentliche Kunstsammlung, Basel – *The elegant stylization of this group of women recalls the paintings of Ancient Egypt and goes far beyond any possible concept of realism.*

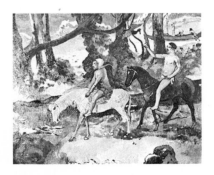

40. The Flight (or The Ford) – 1901. Pushkin Museum, Moscow – *This canvas is an example of the union between Gauguin's primitive painting and the intellectual aspects which inevitably came from his background. In this painting he appears to have drawn his inspiration from Dürer's engraving* Knight, Death and the Devil, *a copy of which he possessed.*

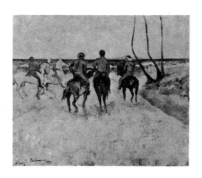

41. Riders on the Beach – 1902. Folkwang Museum, Essen – *The subject of riders, partly influenced by Western art and partly by the fact that there were many horses on the Marquesan Islands, was a frequent one during the last years of Gauguin's life. He himself owned a horse and seeing horses every day must surely account for their sudden dominance in his art.*

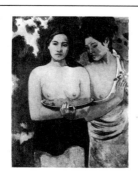

42. Two Tahitian Women (Les Seins aux Fleurs Rouges) – 1899. Metropolitan Museum of Art (Gift of William Church Osborn, 1949), New York – *These two women making offerings of fruit and flowers give the artist the opportunity to construct a harmonious, musical composition by means of the unusual use of colour.*

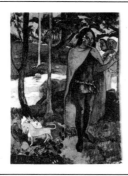

43. The Witch Doctor of Hiva Oa – 1902. Musée d'Art Moderne, Liège – *This, one of the last of Gauguin's works, shows the magic figure of a sorcerer in the foreground. The eye is captivated by the perfectly drawn face and extravagant attire.*

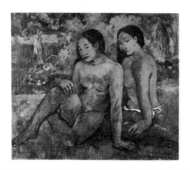

44. And the Gold of Their Bodies – 1901. Musée du Louvre, Paris – *The rhythm, balance, and sensuality of this work draw their inspiration from the representation of the sculptured figures on the Buddhist temple of Borobudur on the island of Java, one of the largest monuments in Indonesia. Gauguin is known to have possessed a photograph of the temple.*

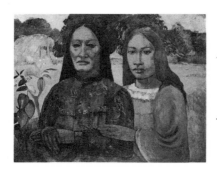

45. Portraits of Women – 1899-1900. Private collection – *This unsigned, undated painting was based on a photograph, probably taken by Henri Lemasson, which was in Gauguin's possession. The artist has changed the background (which was originally a house and not a landscape) and has concentrated all his attention on the faces of the two women.*

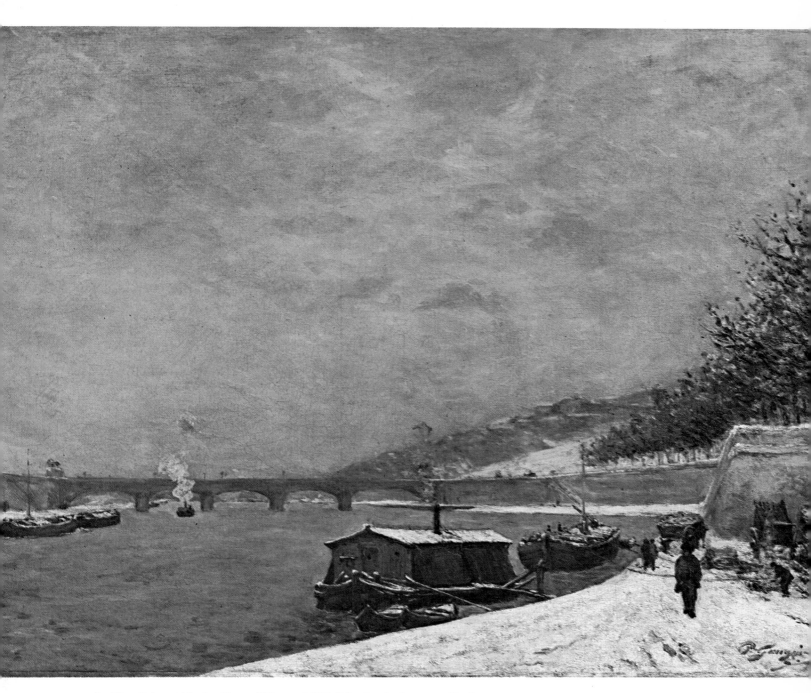

1. *The Seine with the Pont d'Iéna* – 1875. Musée du Louvre, Paris

2. Self-Portrait Dedicated to My Friend Daniel – 1897. Musée d'Orsay, Paris

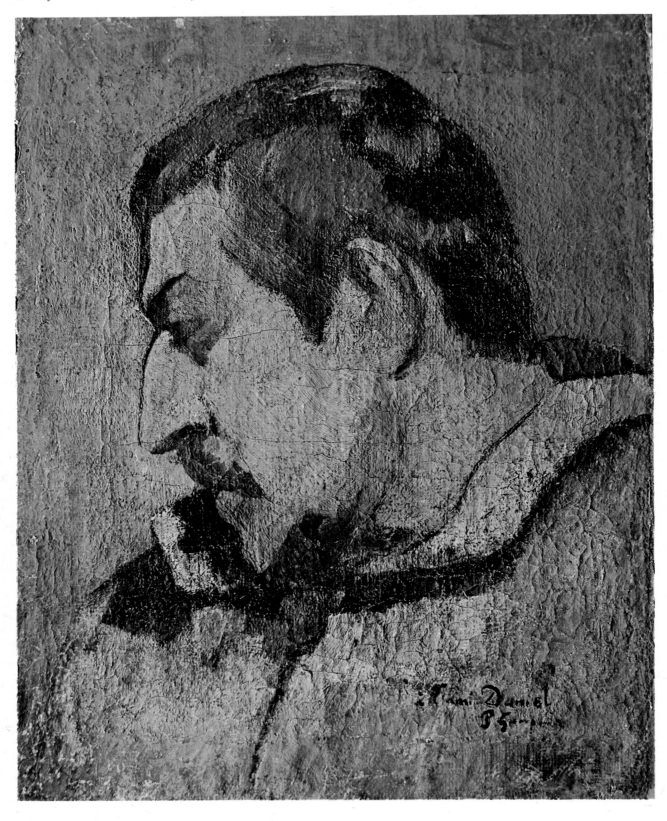

3. Portrait of the Artist's Mother – 1890. Staatsgalerie, Stuttgart

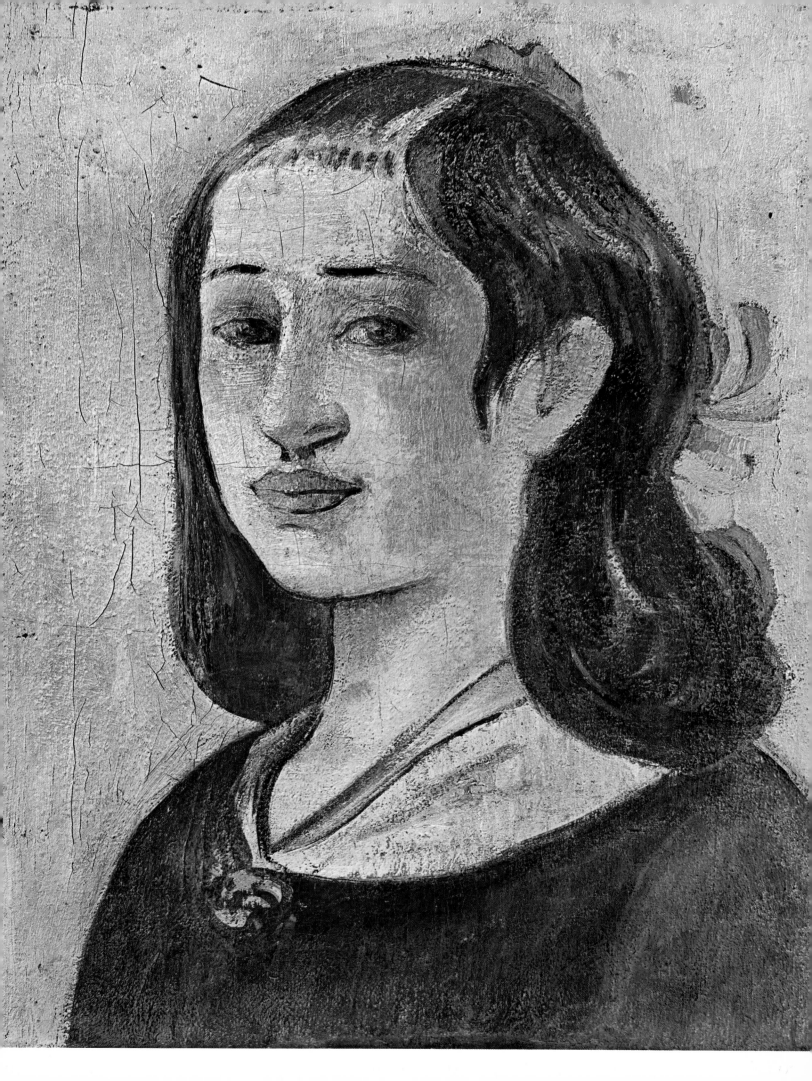

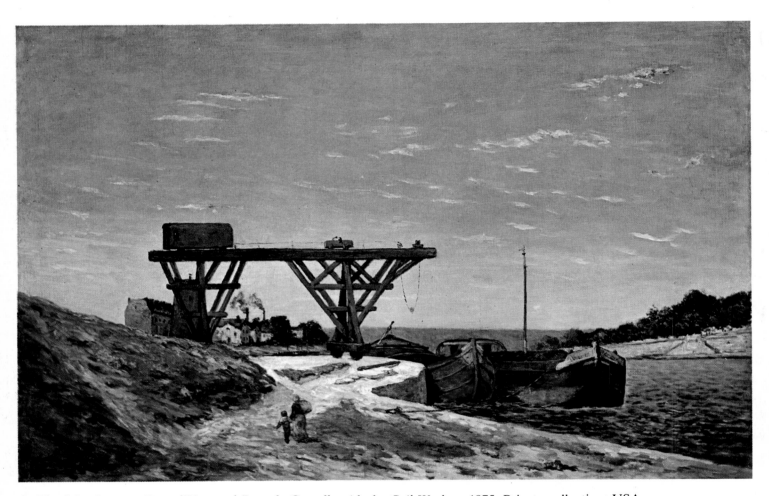

4. *The Seine between Pont d'Iéna and Pont de Grenelle with the Cail Works* – 1875. Private collection, USA

5. *Apple Trees in Blossom* – 1879. Private collection, USA

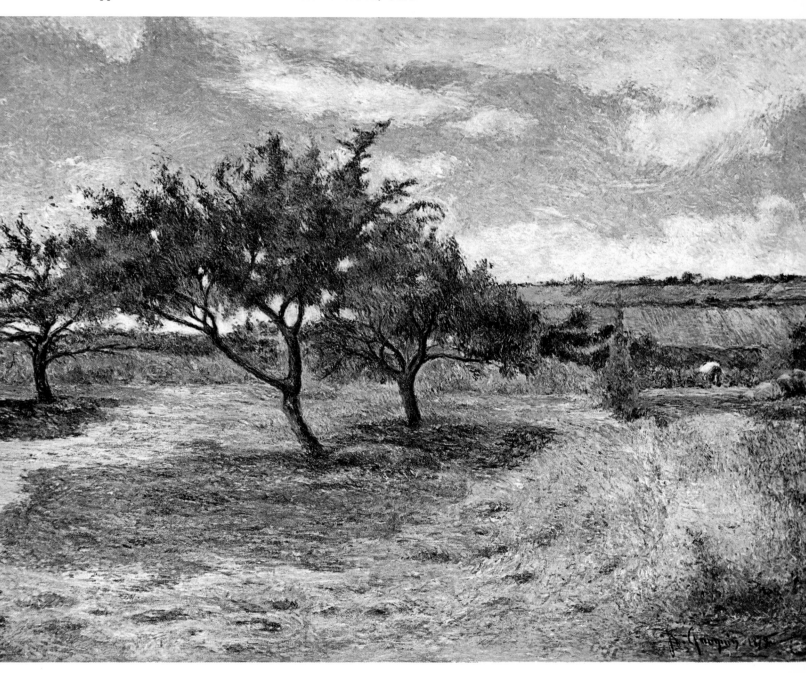

6. *Self-Portrait at the Easel* – 1885. Private collection, Bern

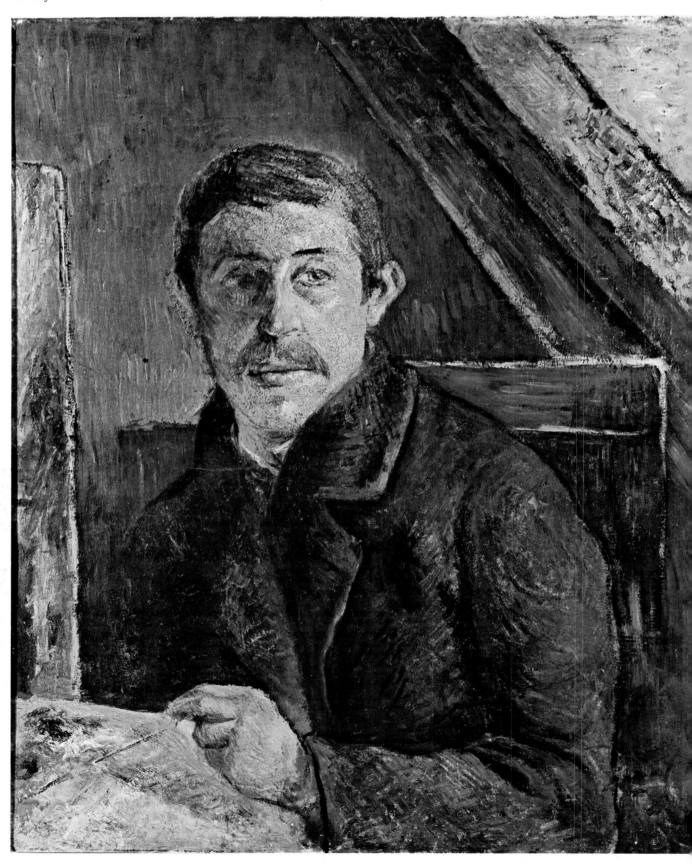

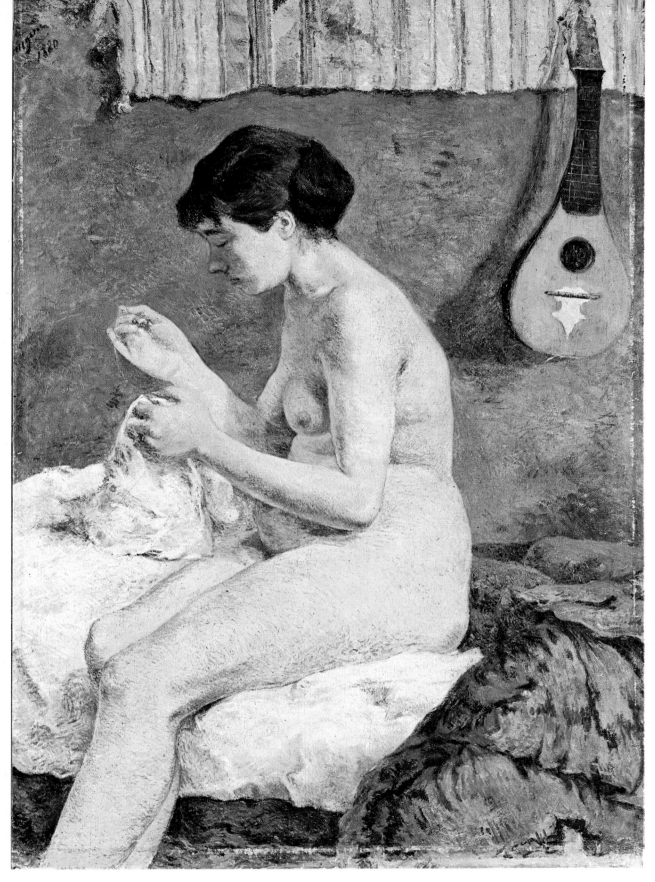

7. *Study of a Nude (Suzanne Sewing)* – 1880. Ny Carlsberg Glyptotek, Copenhagen

8. *Asters on a Bureau* – 1886. Private collection

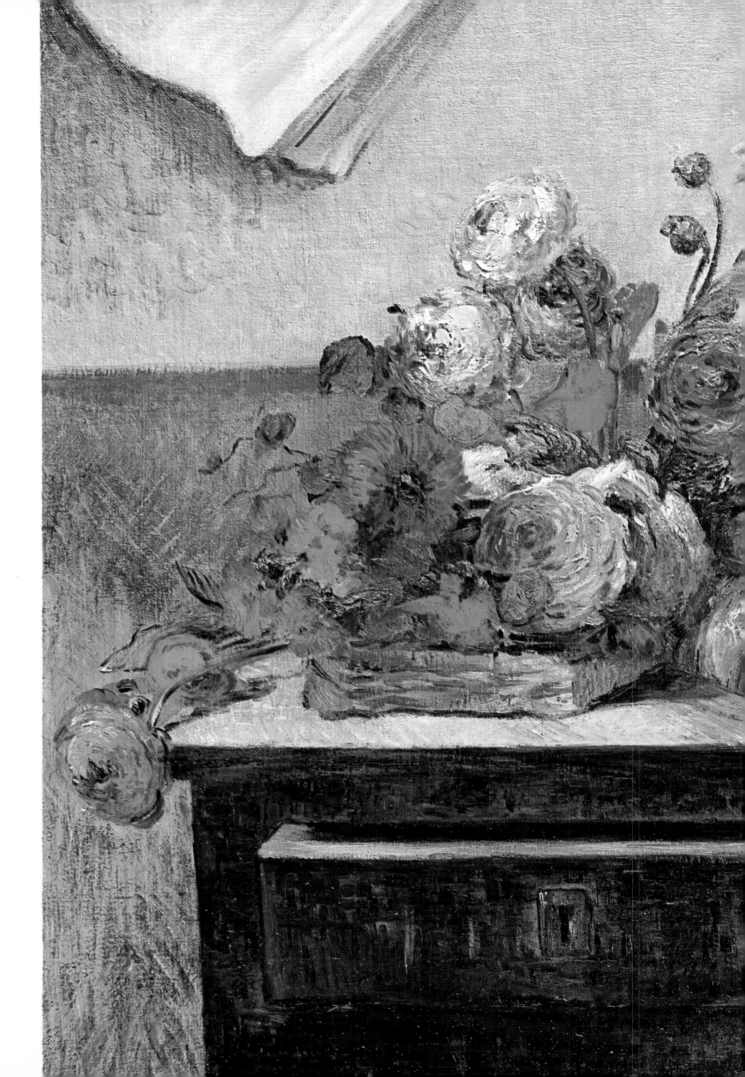

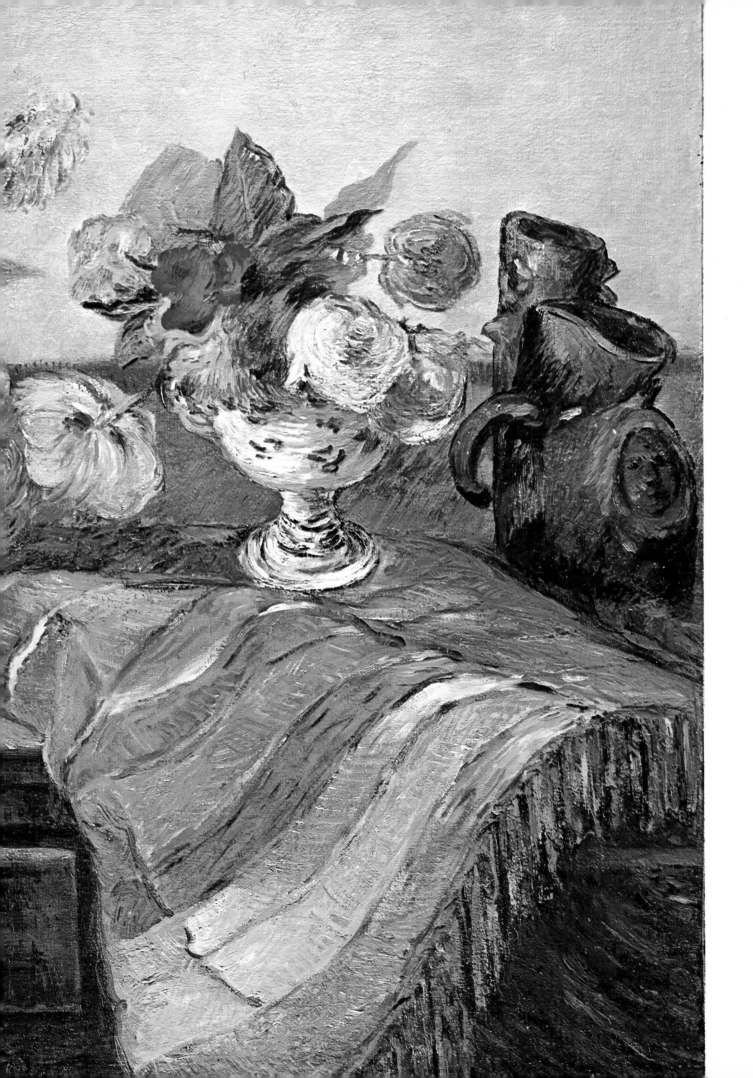

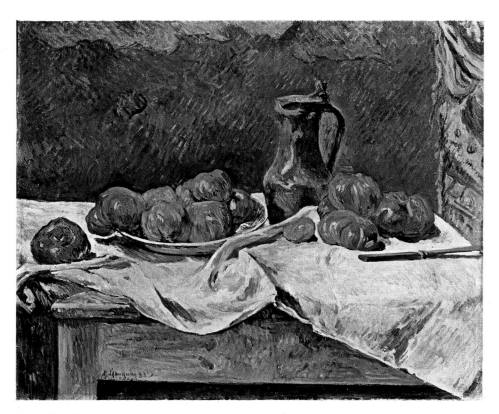

9. *Still-Life with Tomatoes* – 1883. Private collection

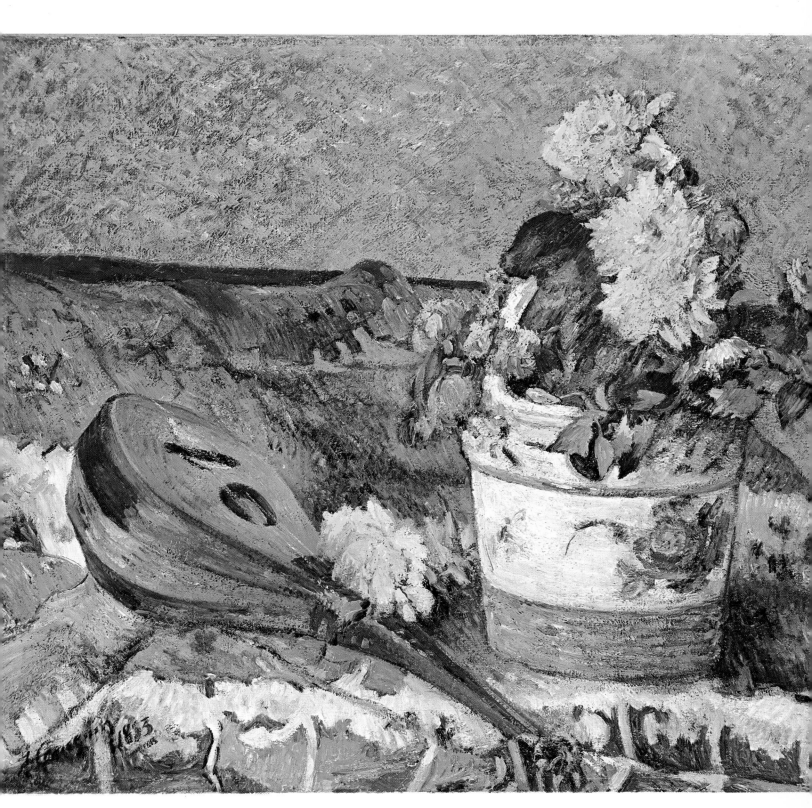

10. *Mandolin and Pot of Flowers* – 1883. Private collection, USA

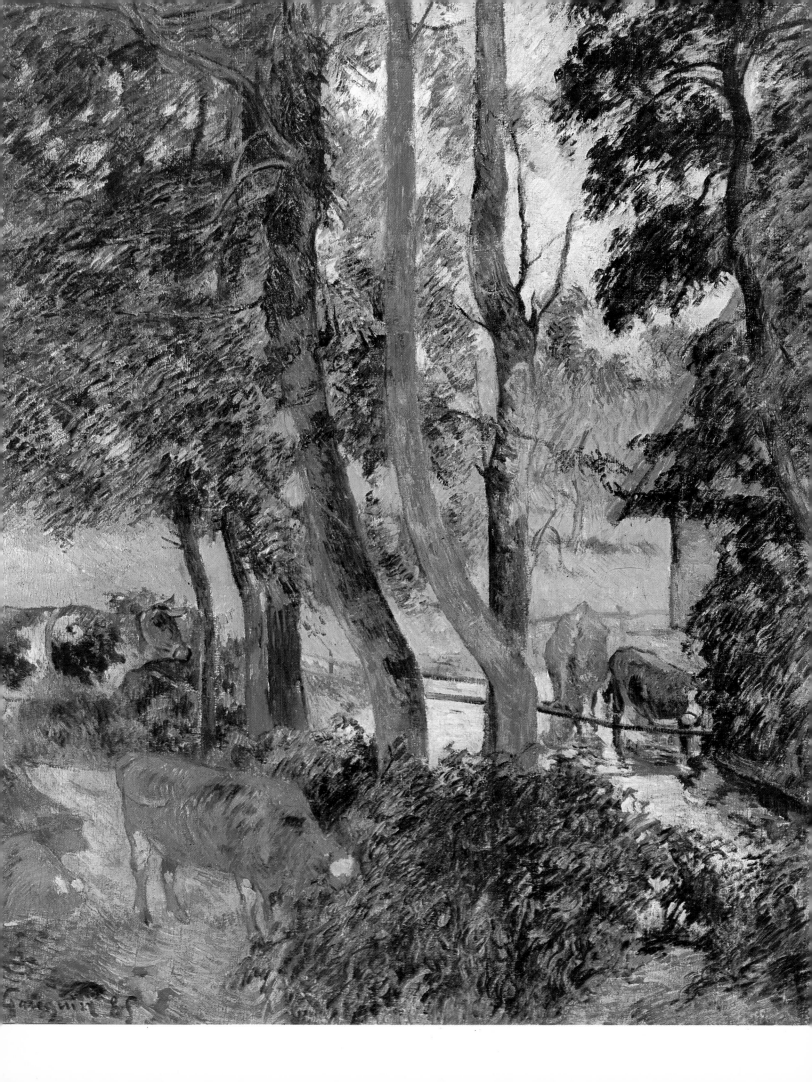

11. *Pond with Cattle* – 1885. Galleria d'Arte Moderna (Grassi Collection), Milan

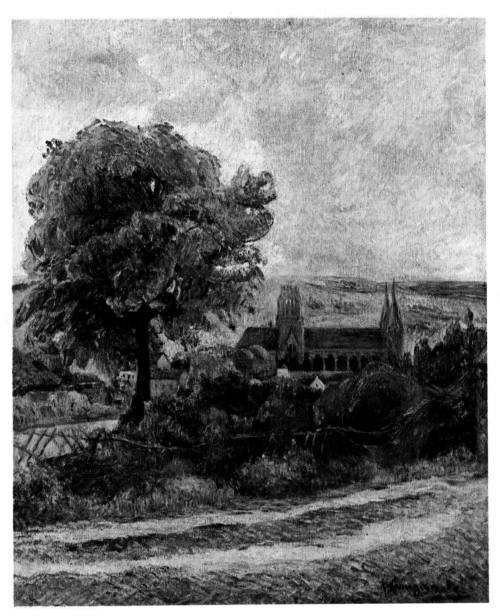

12. *Rouen, Church of Saint-Ouen* – 1884. Private collection, USA

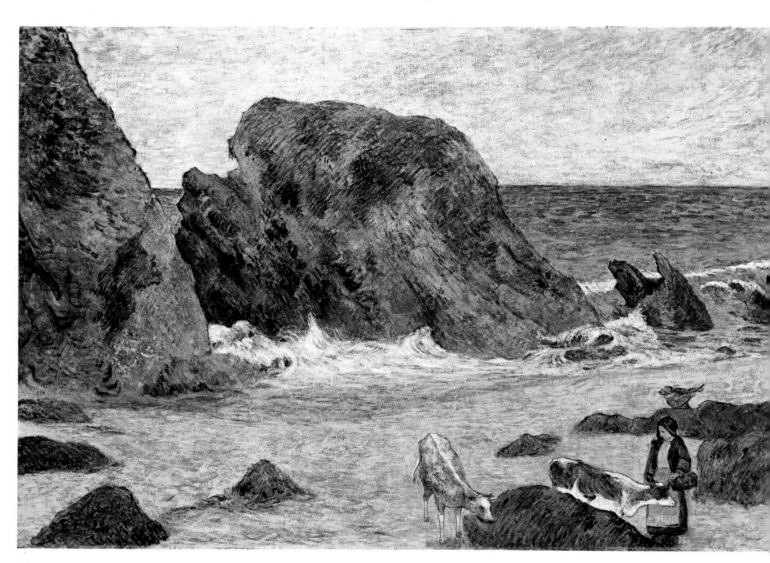

13. *Breton Coast with Girl and Cows* – 1886. Private collection, USA

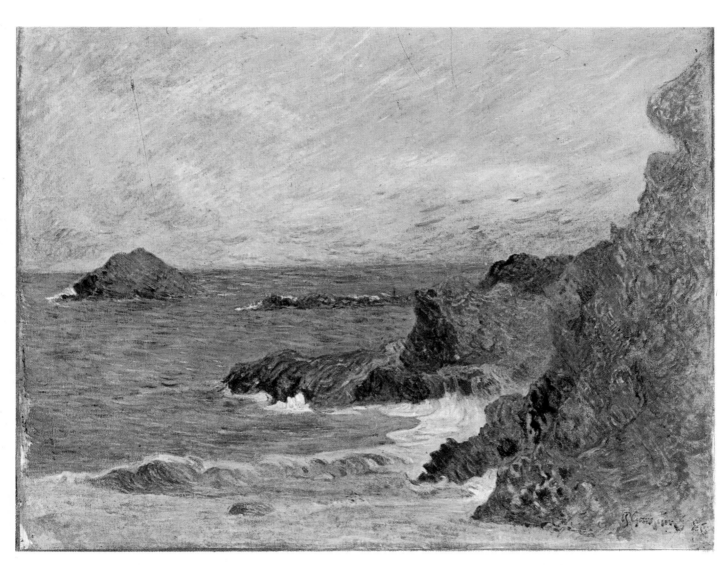

14. *Breton Coast* – 1886. Konstmuseum, Gothenburg

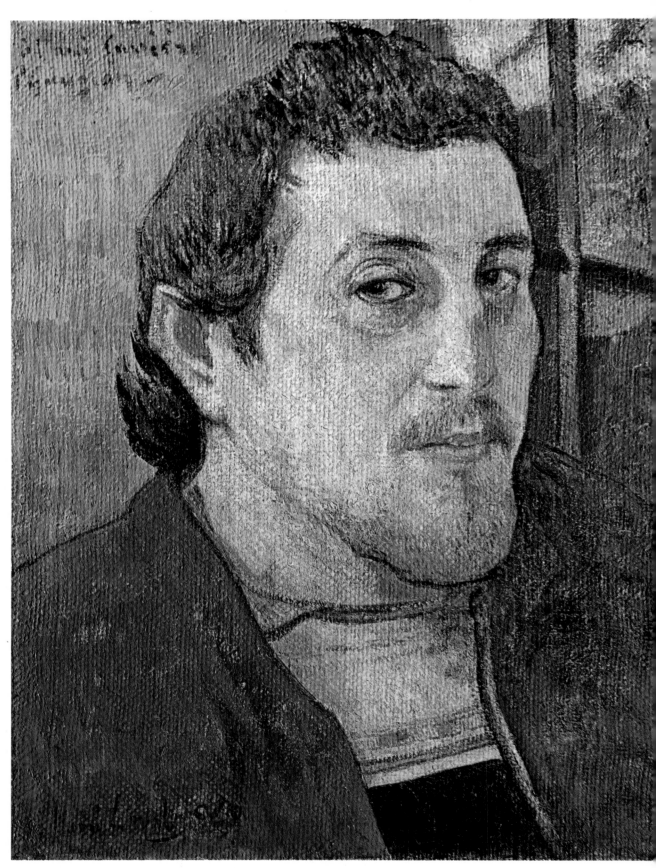

15. *Self-Portrait Dedicated to Eugène Carrière* – 1890. National Gallery of Art
(Mr and Mrs Paul Mellon Collection), Washington, D.C.

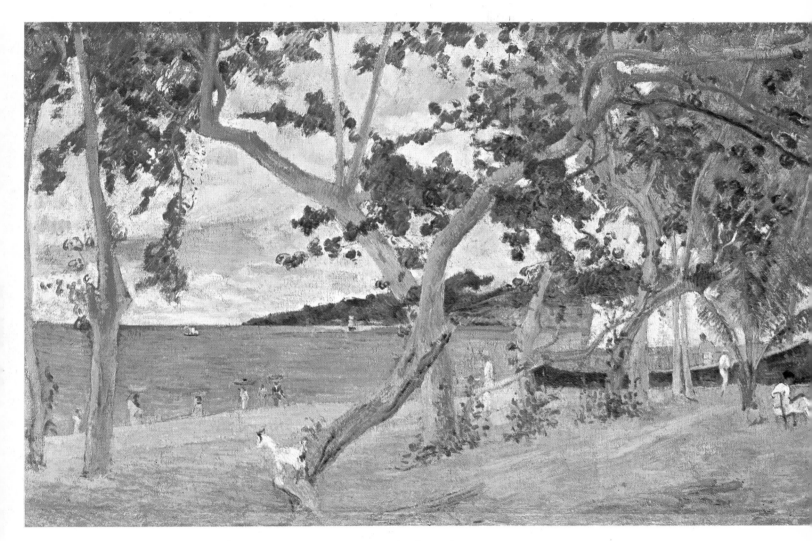

16. *By the Seashore (Martinique)* – 1887. Ny Carlsberg Glyptotek, Copenhagen

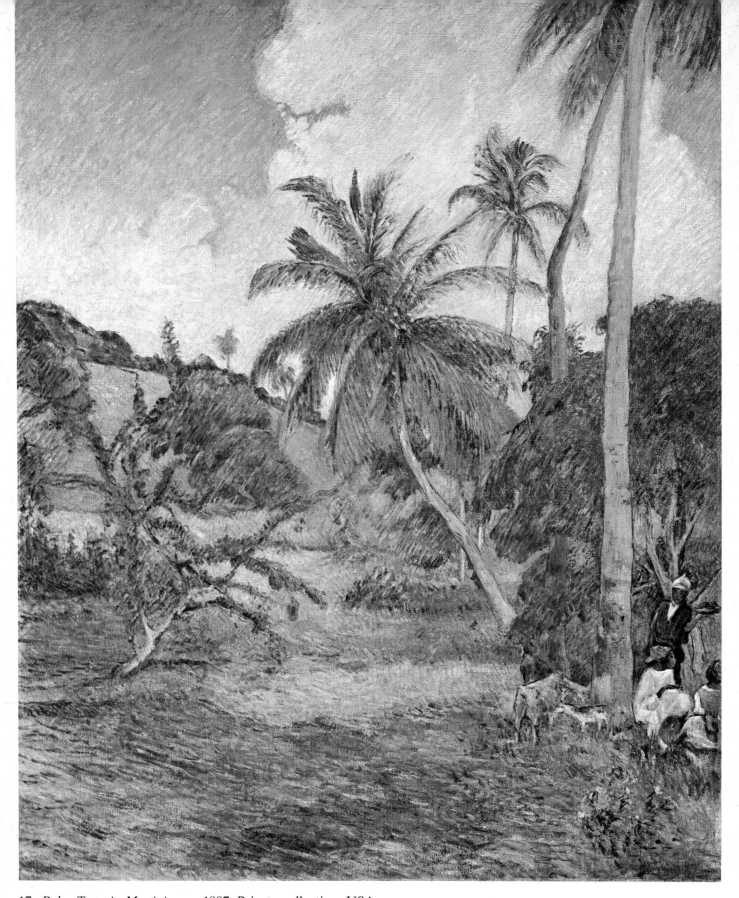

17. *Palm Trees in Martinique* – 1887. Private collection, USA

18. *Huts under the Trees (Martinique)* – 1887. Private collection, USA

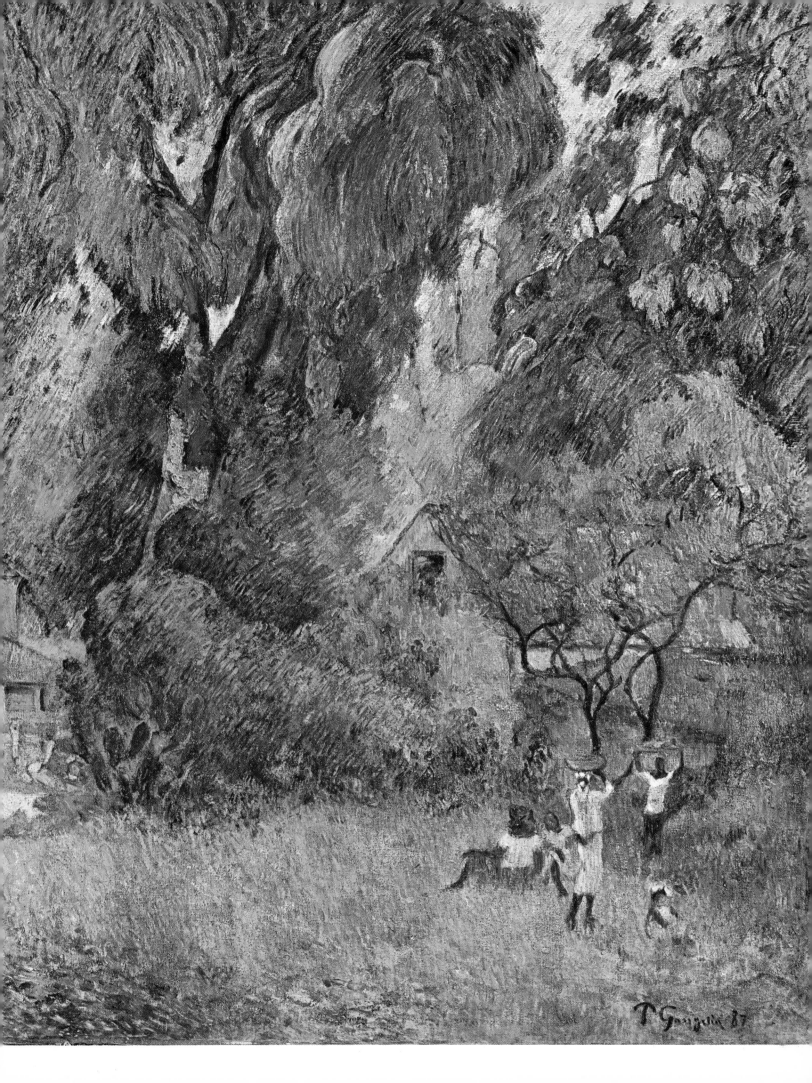

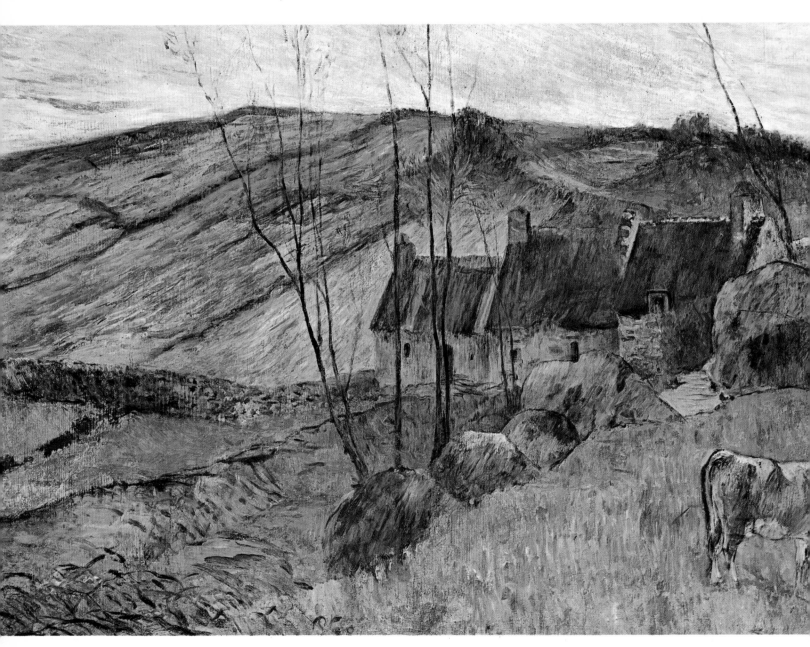

19. *Breton Landscape* – 1888. Private collection

20. *Portrait of Madeleine Bernard* – 1888. Musée de Peinture et de Sculpture, Grenoble

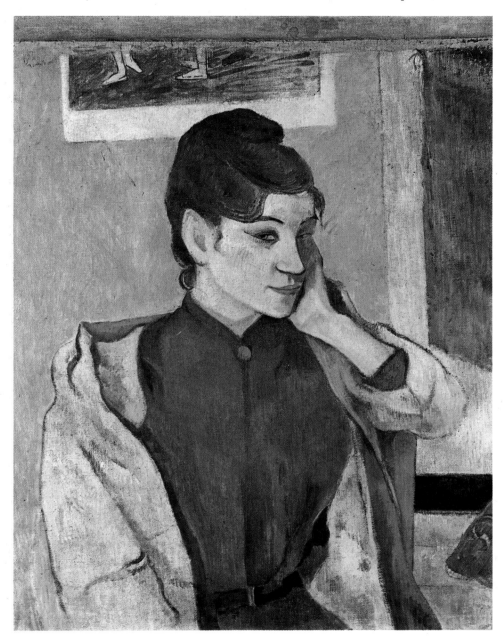

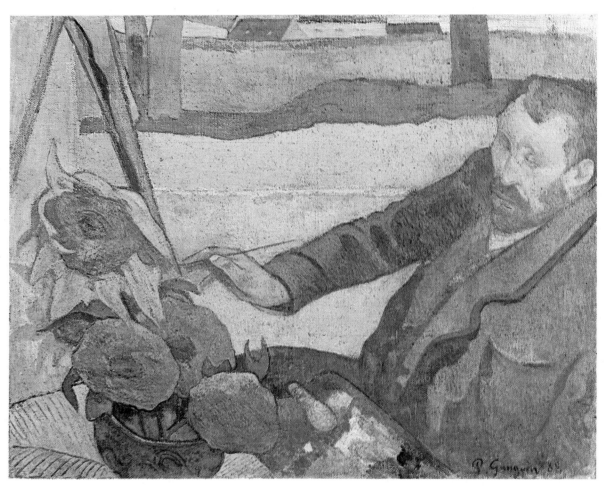

21. *Portrait of Van Gogh Painting Sunflowers in Arles* – 1888. Vincent Van Gogh Foundation, Amsterdam

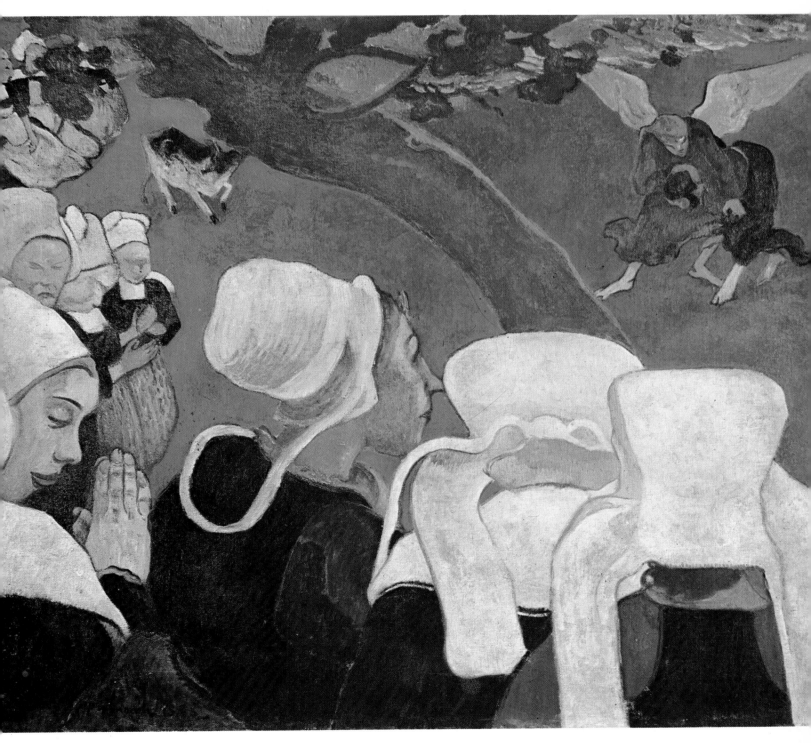

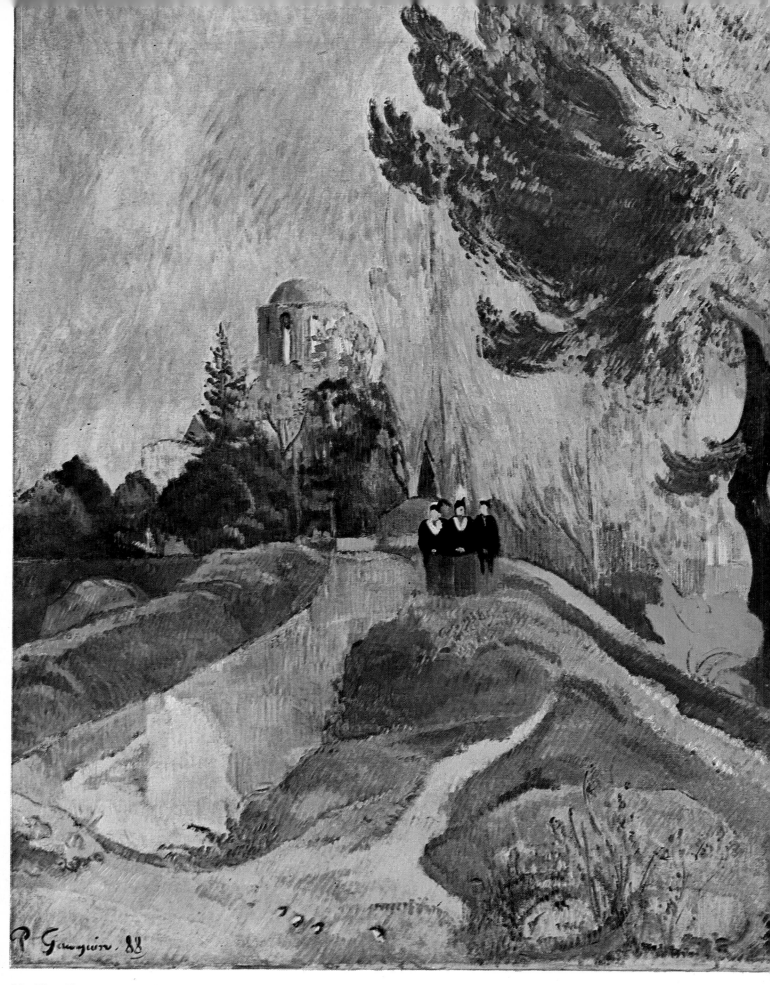

23. *The Alyscamps in Arles* – 1888. Musée d'Orsay, Paris

24. *Women of Arles* – 1888. Art Institute of Chicago (Mr and Mrs Lewis L. Coburn Memorial Collection)

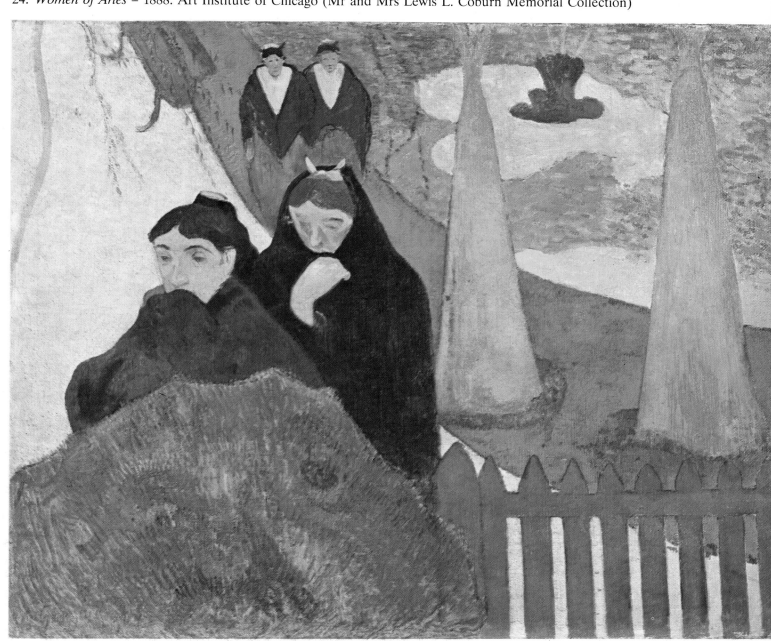

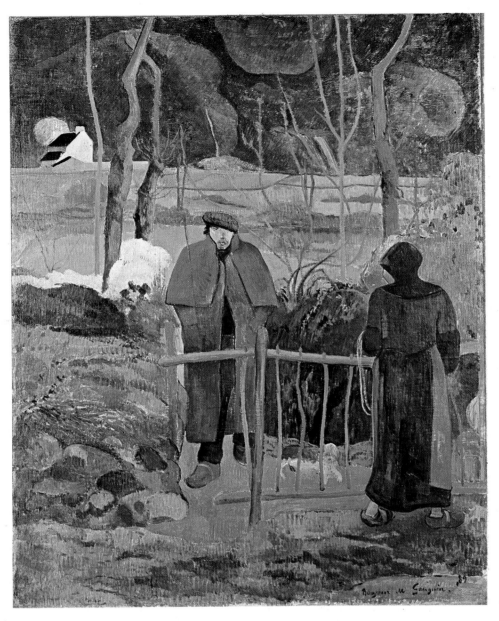

25. *Bonjour Monsieur Gauguin* – 1889. Museum of Modern Art, Prague

26. *La Belle Angèle at Le Pouldu (Portrait of Madame Angèle Satre)* – 1889. Musée d'Orsay, Paris

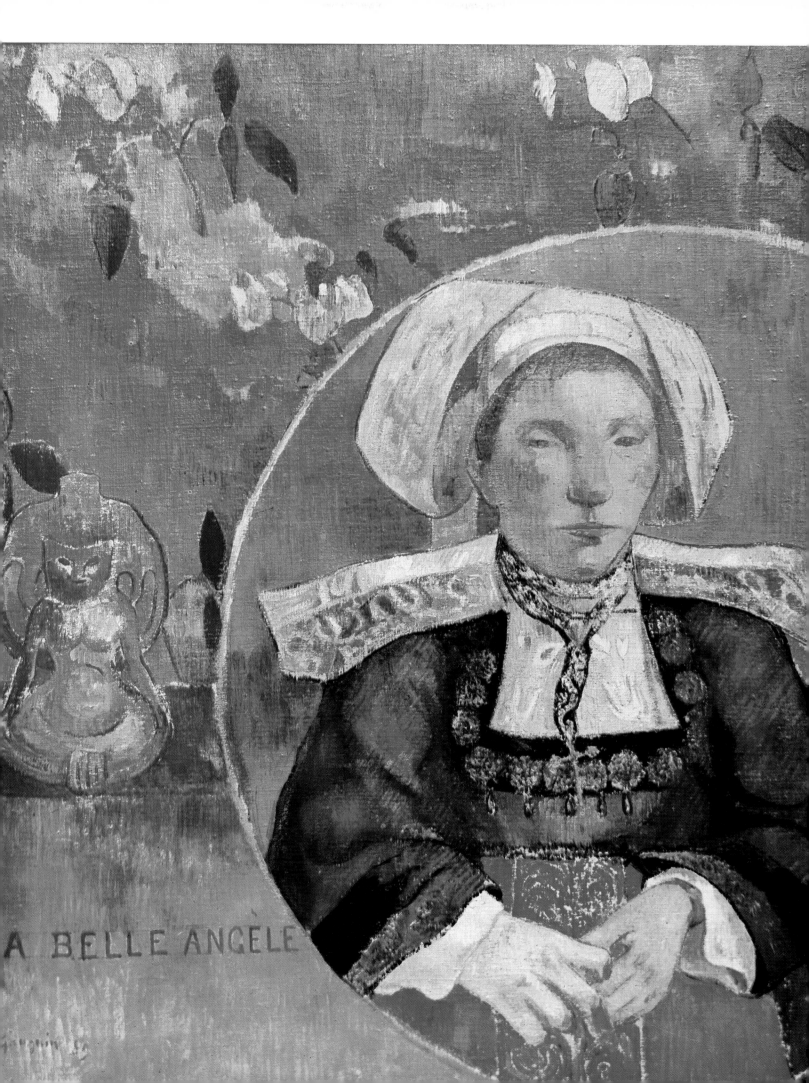

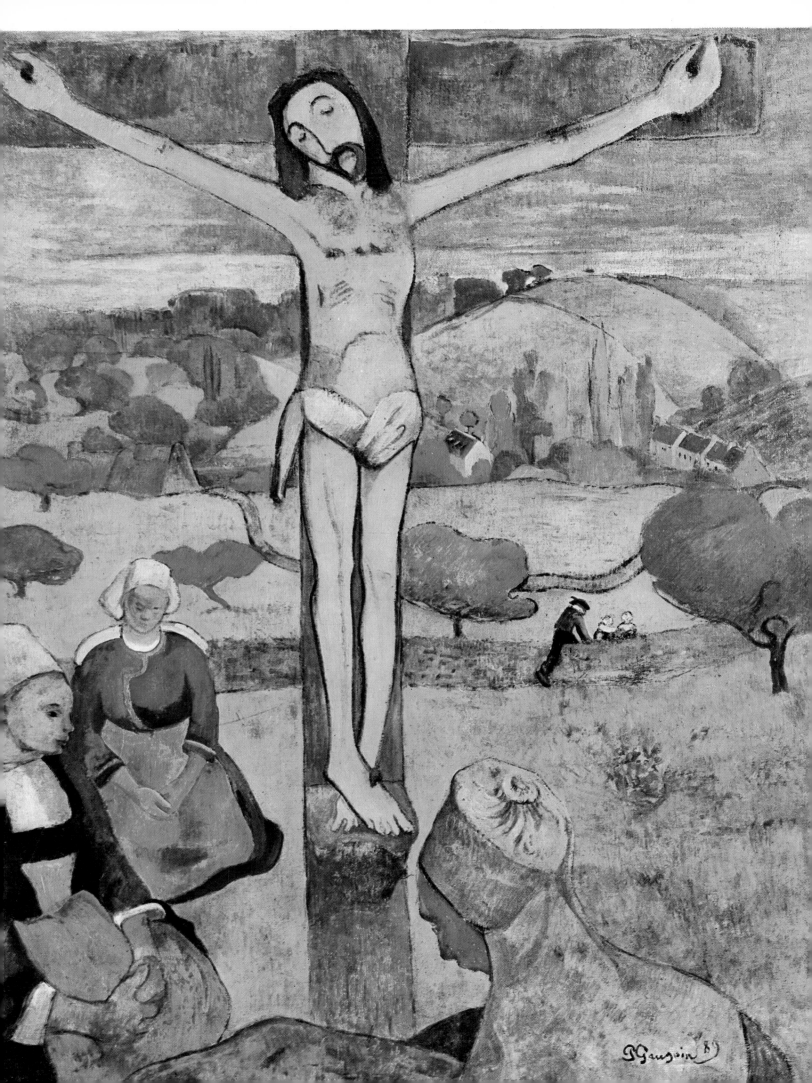

27. *The Yellow Christ* – 1889. Albright-Knox Art Gallery, Buffalo, N.Y.

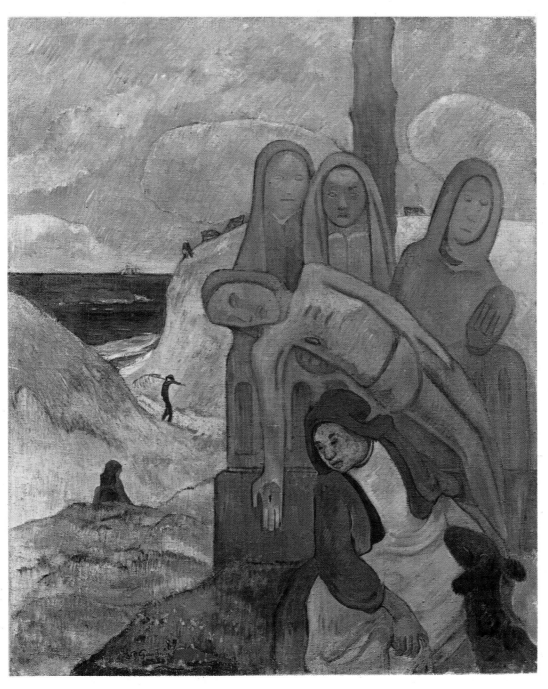

28. *The Green Christ (Breton Calvary)* – 1889. Musées Royaux des Beaux Arts de Belgique, Brussels

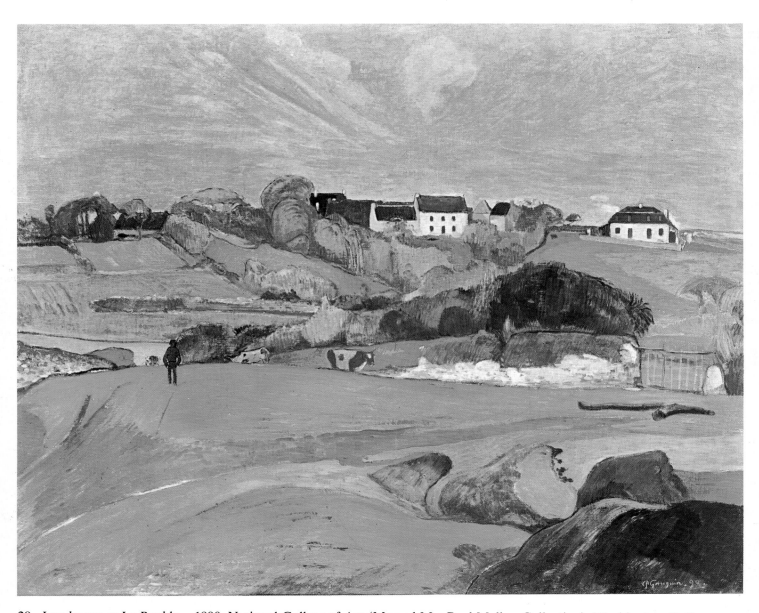

29. *Landscape at Le Pouldu* – 1890. National Gallery of Art (Mr and Mrs Paul Mellon Collection), Washington, D.C.

30. *The Blue Roof (Farmyard at Le Pouldu)* – 1890. Private collection

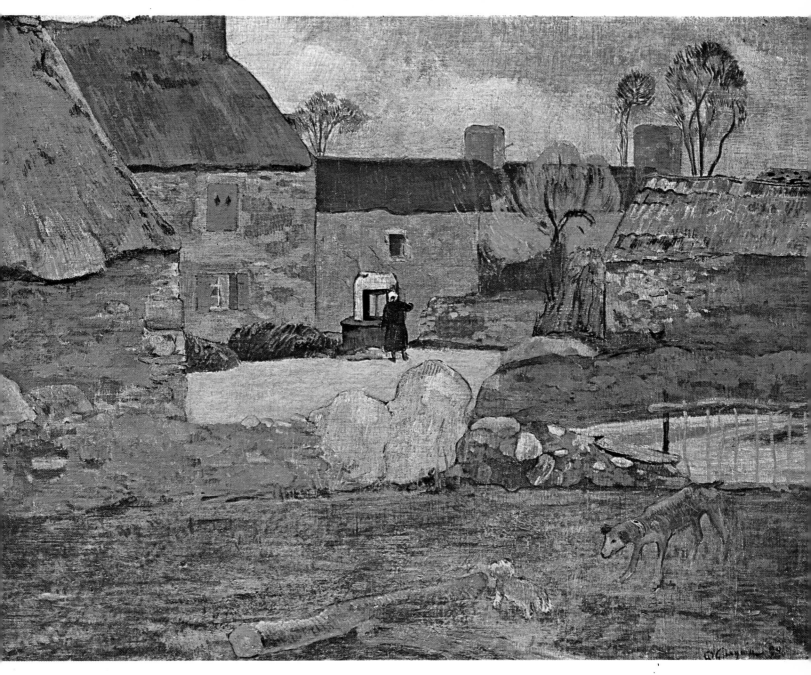

31. *Roses and Statuette* – c. 1890. Musée Saint-Denis, Reims

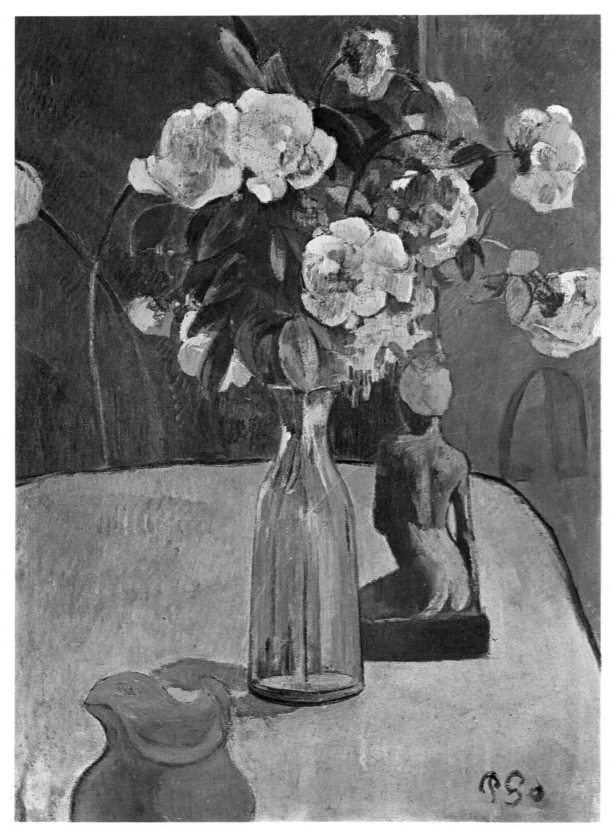

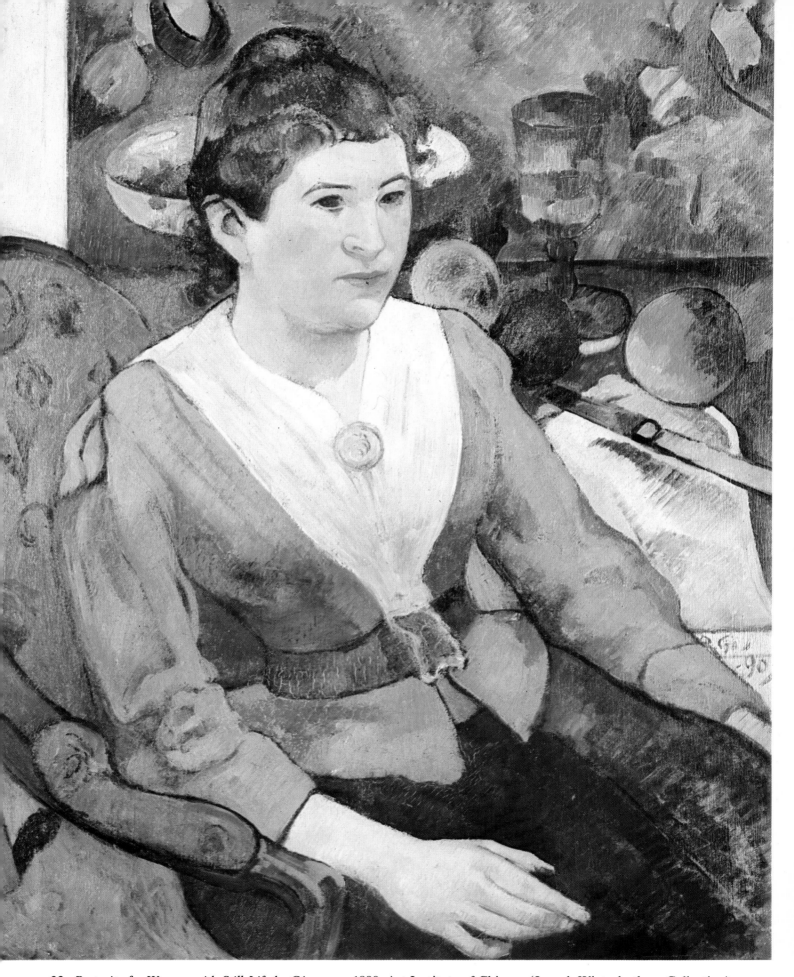

32. *Portrait of a Woman with Still-Life by Cézanne* – 1890. Art Institute of Chicago (Joseph Winterbotham Collection)

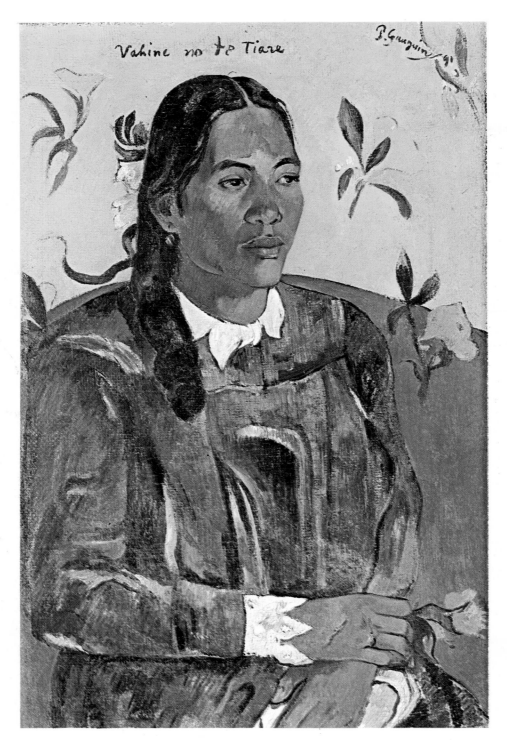

33. *Tahitian Woman with Flowers ("Vahine No Te Tiare")* – 1891.
Ny Carlsberg Glyptotek, Copenhagen

34. *Two Tahitian Women on the Beach* – 1891. Musée d'Orsay, Paris

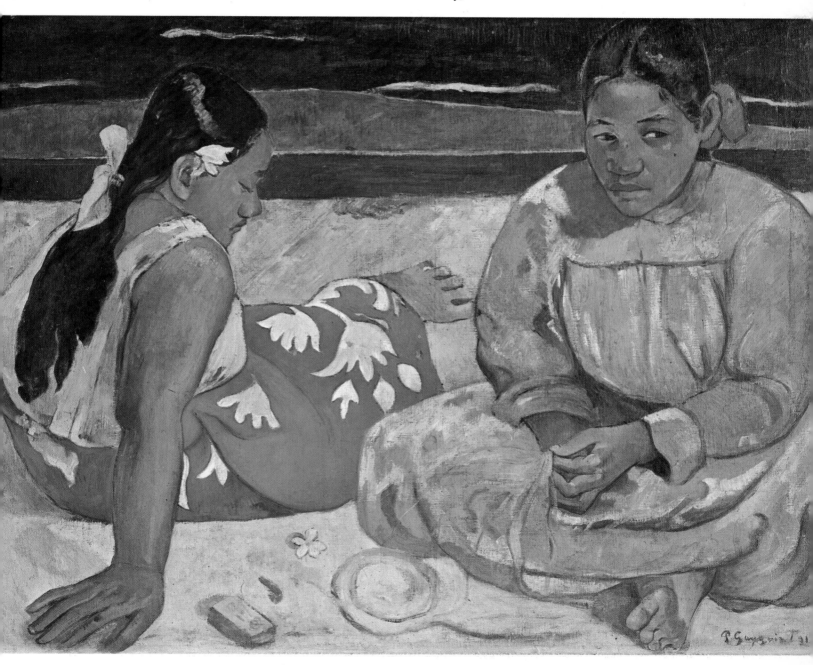

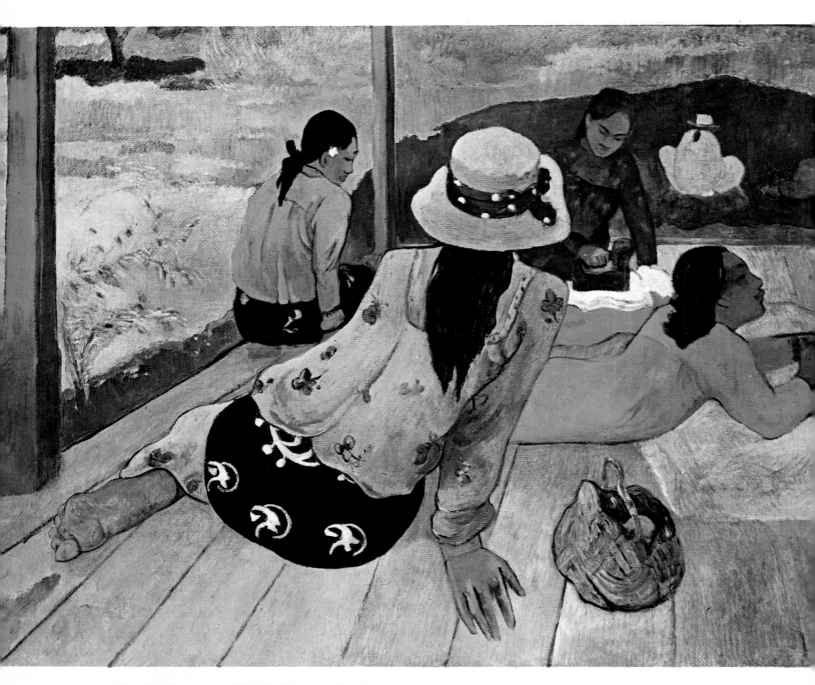

35. *The Siesta* – c. 1891-92. Private collection

36. *Annah the Javanese ("Aita Tamari Vahine Judith Te Parari")* – 1893-94. Private collection

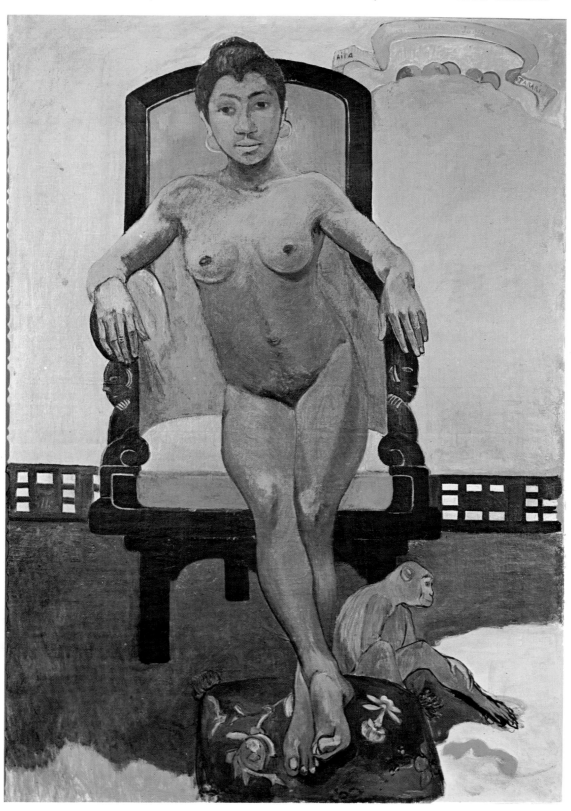

37. *The Birth of Christ, Son of God ("Te Tamari No Atua")* – 1895-96. Bayerische Staatsgemäldesammlungen, Munich

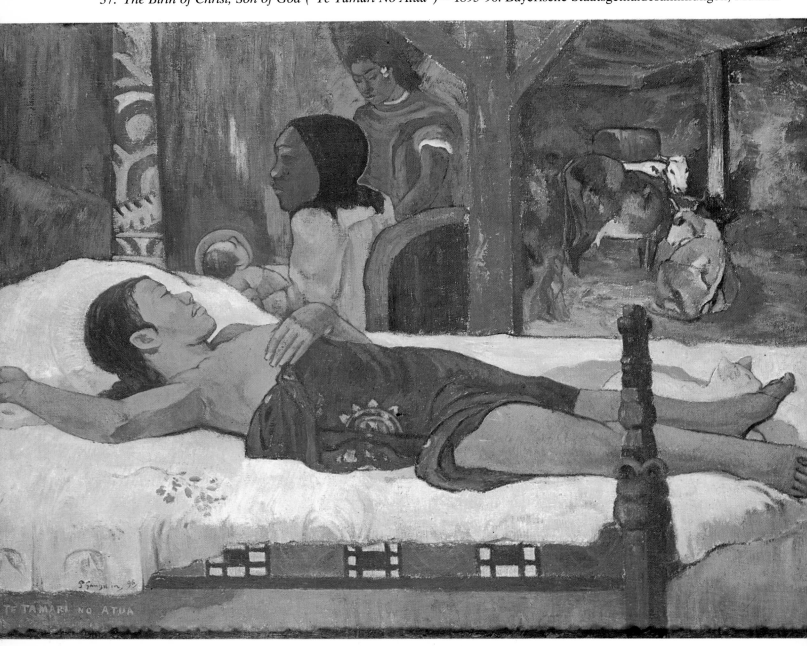

38. *Tahitian Pastoral ("Faa Iheihe")* – 1898. Tate Gallery, London

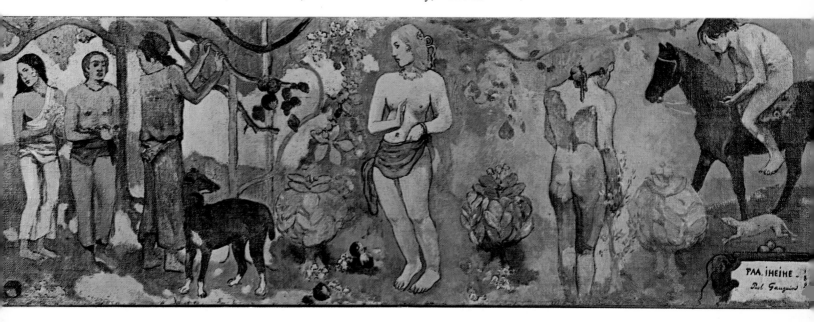

39. *We Shall Not Go to Market Today ("Ta Matete")* – 1892. Oeffentliche Kunstsammlung, Basel

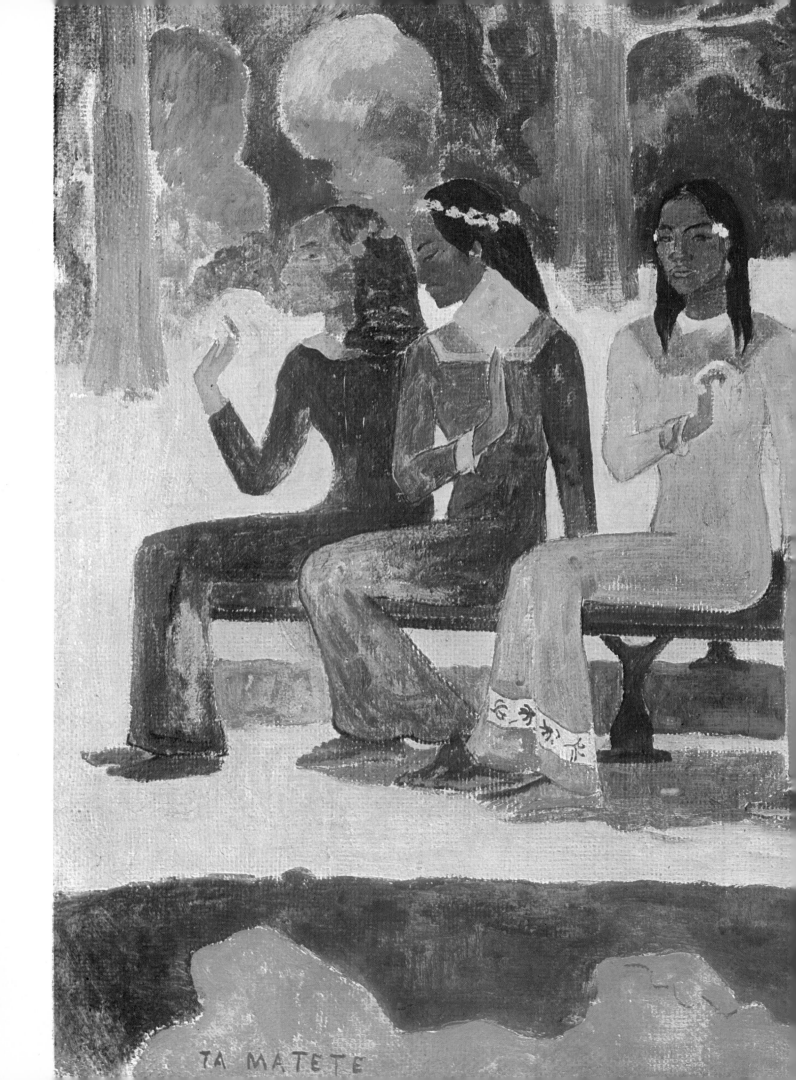

TA MATETE

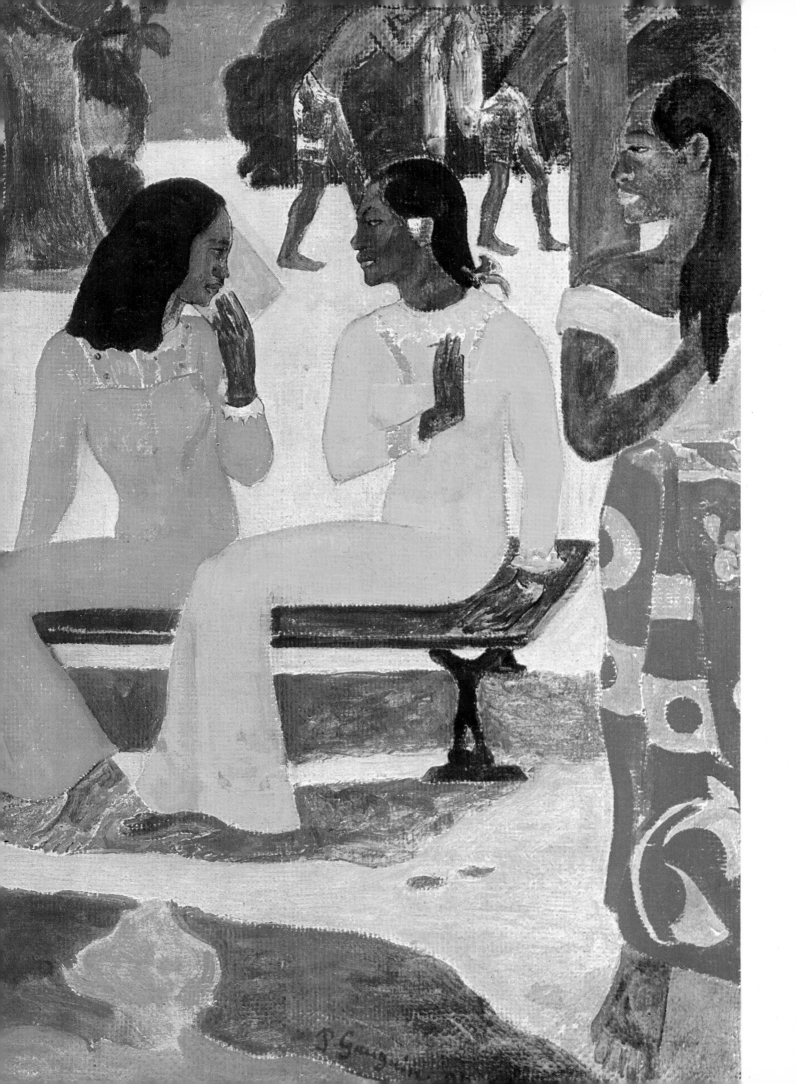

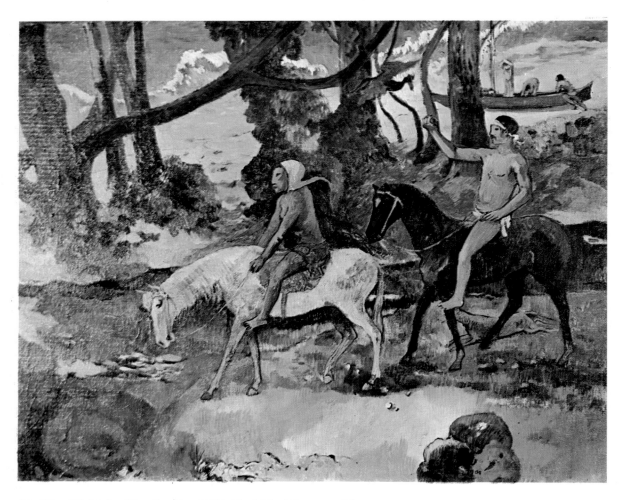

40. *The Flight (or The Ford)* – 1901. Pushkin Museum, Moscow

41. *Riders on the Beach* – 1902. Folkwang Museum, Essen

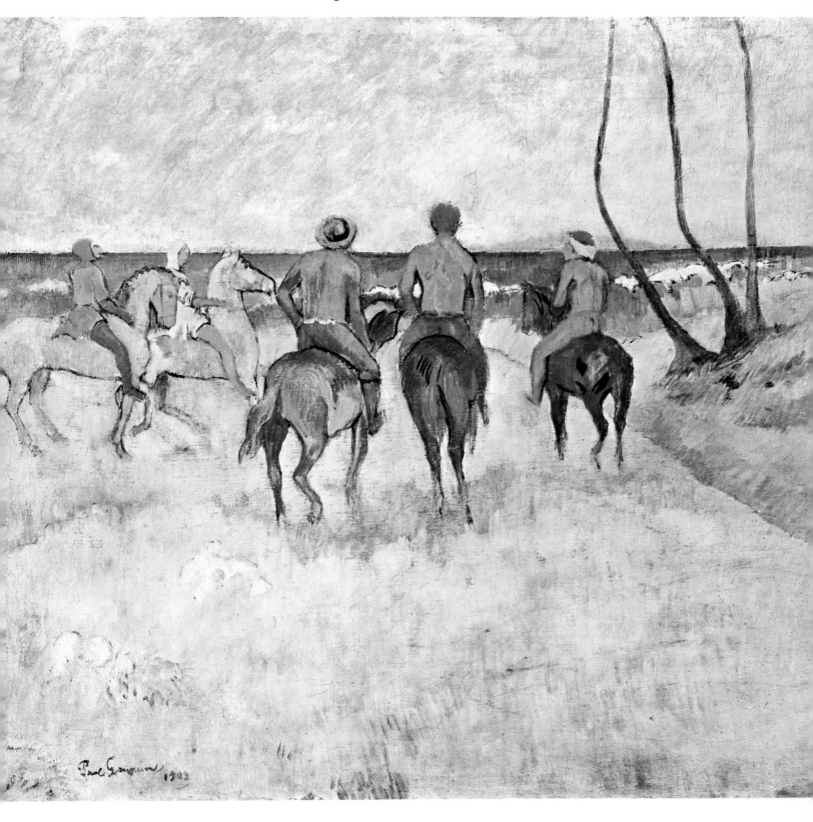

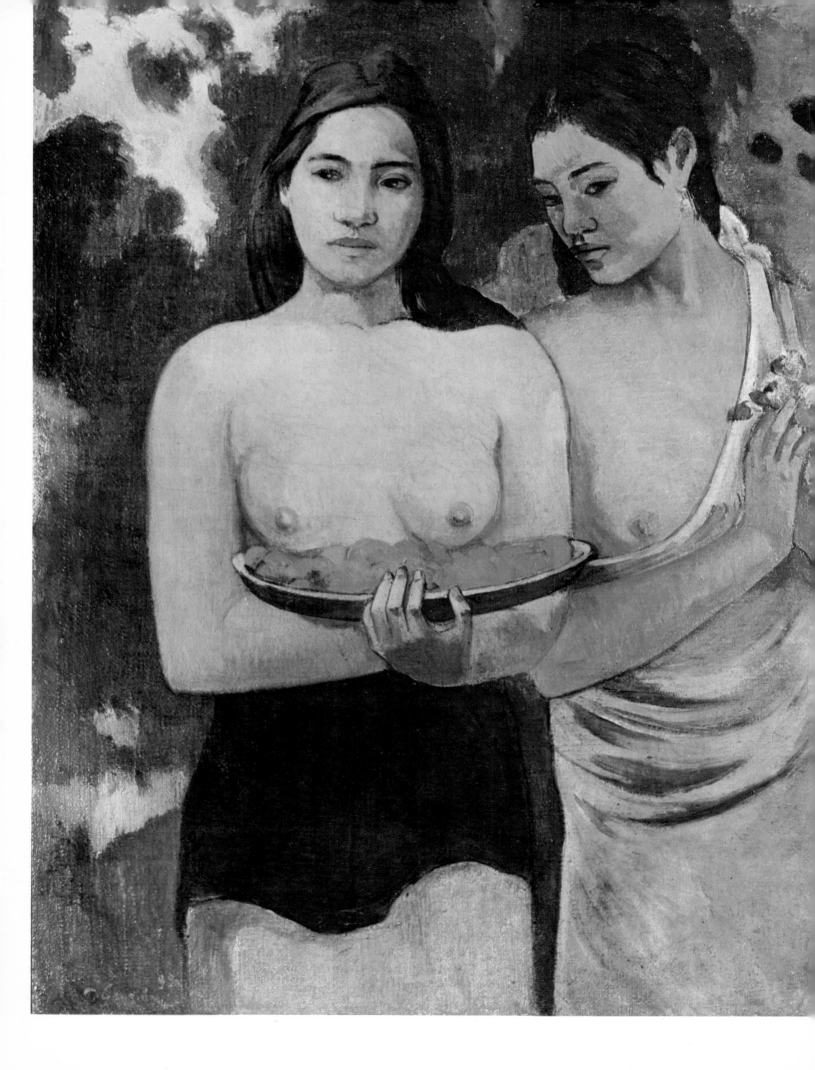

42. *Two Tahitian Women (Les Seins aux Fleurs Rouges)* – 1899. Metropolitan Museum of Art (Gift of William Church Osborn, 1949), New York

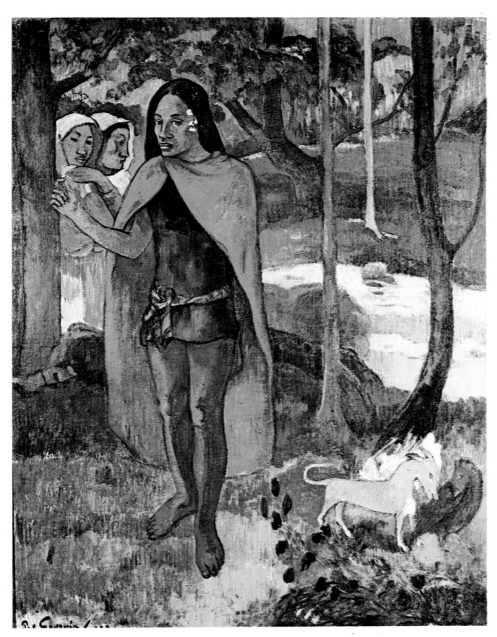

43. *The Witch Doctor of Hiva Oa* – 1902. Musée d'Art Moderne, Liège

44. *And the Gold of Their Bodies* – 1901. Musée du Louvre, Paris

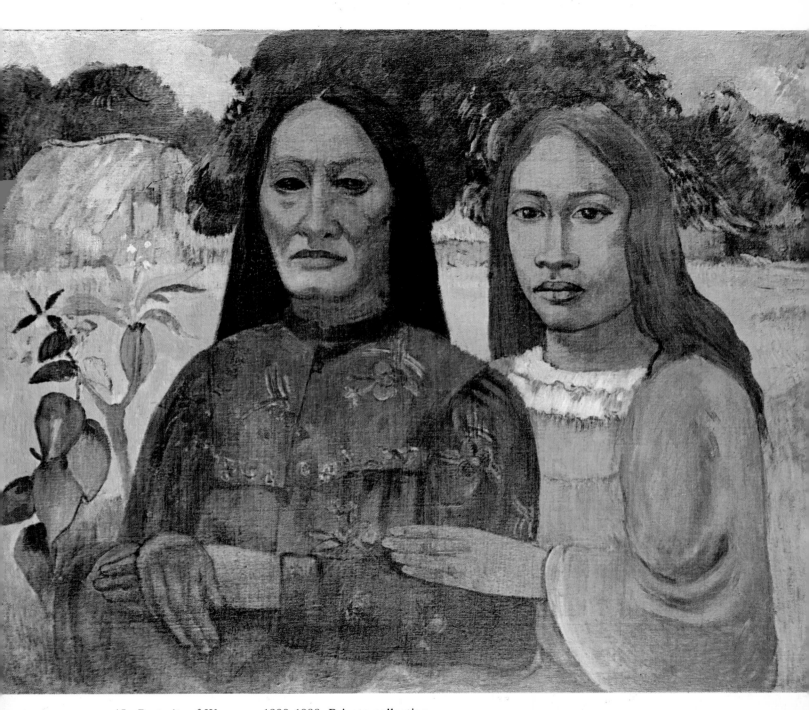

45. *Portraits of Women* – 1899-1900. Private collection

Editor in chief Anna Maria Mascheroni

Art director Luciano Raimondi

Text Marina Robbiani

Translation Terry Rogers

Production DIMA & B, Milan

Photo Credits Gruppo Editoriale Fabbri S.p.A., Milan

ISBN 2-89393-041-7

Printed in Italy by Gruppo Editoriale Fabbri S.p.A., Milan